# Southport, Oak Island, and Bald Head Island

POSTCARD HISTORY SERIES

# *Southport, Oak Island, and Bald Head Island*

*Daniel Fink*

ARCADIA
PUBLISHING

Published by Arcadia Publishing
Charleston, South Carolina

Printed in the United States of America

Library of Congress Control Number: 2013934580

For all general information contact Arcadia Publishing at:
Telephone 843-853-2070
Fax 843-853-0044
E-mail sales@arcadiapublishing.com
For customer service and orders:
Toll-Free 1-888-313-2665

Visit us on the Internet at www.arcadiapublishing.com

*I dedicate this book to my best friend, my soul mate,
my wife, Charen, and to our wonderful family.
I also thank my neighbors, past, present, and future,
who made this possible.*

# CONTENTS

# ACKNOWLEDGMENTS

If it takes a village to raise a child, then it takes a mountain of perseverance to write a book. Many have come forward to help me mold and give life to this project. My wife, Charen, must come first. Her encouragement and copious knowledge bank left no question unanswered. Our family and friends have supported me completely. My hope is to recognize all who have helped. If any were missed, it was not intentional.

I am extremely grateful to Marty and Joe Loughlin, Eleanor Loughlin, the Southport Historical Society, Larry Maisel, Jim Pittman, Jack Majernik, Beth Majernik, Chuck Roedema, Jim McKee, Bert Felton, Musette Steck, John and Heather Majernik, the *State Port Pilot*, the spirit of Susan Carson, Bill Reaves, the North Carolina Baptist Assembly at Fort Caswell, the *Southport Times*, Ben Celinski, and Katie McAlpin.

I must also thank Chris, Maritsa, Alexandria, and Annie Fink for their undying support of whatever I do. First, last, and always, I must thank my maker for the ability given to me that makes this possible.

All images in this book are courtesy of Ben Celinski and the *Southport Times*.

# INTRODUCTION

The *Southport Times* has an extensive postcard collection of Southport and the surrounding area. My goal is to provide a written caption for each card and give the reader a historical glimpse back in time to objects that may no longer exist. Some cards date to 1906 and are quite rare. Our journey begins in that little town that was first known as Smithville.

For many years, Indians came to the great fishing grounds of the lower Cape Fear River. To mark this trail, a sapling was bent to blaze the path. This beautiful gnarled live oak tree is now over 800 years old. *Ripley's Believe It or Not!* claims it is one of only five such trees still standing in America. It has become a Southport landmark. By 1720, the 1,000 or so Native Americans in the area were gone, and it was time for expansion, military protection, and discovery by Europeans, adventurers, explorers, and pirates. North Carolina, one of the original 13 colonies, had only one seaport, Wilmington, which was already 60 years old. The fort at the mouth of the Cape Fear River was a great place to start a town, and this became the dream of Joshua Potts. With the help of Benjamin Smith, he created the town of Smithville on December 31, 1792.

This book explores the beginning of Smithville and the causes of its growth. The Civil War and, more importantly, Reconstruction led to the decision to rename the town Southport, which sounds more nautical and fit better in the time of great progress between 1878 and 1899. A new century and World War I touched Southport, and the time between World War I and World War II gave rise to the "smell of Southport gold," or menhaden fishing. This oily, smelly, and hardly edible fish was in great demand for a rapidly industrializing nation. A saying at the time went, "When the pogies [menhaden] are running, there will be butter for your bread." The never-to-be-forgotten 1920s were good to Southport, pointing to its role as a military town from 1941 to 1945.

It is important to remember how the past is a prologue to the future. Joshua Potts could never have imagined that the "salubrious breezes" that cured his debilitating fever would help Southport become the "worst-kept secret in North Carolina."

Before Smithville was founded, "King" Roger Moore started Orton Plantation in 1725. His high-handed ways angered the Indians, and they burned his first building to the ground. The second building, constructed in 1735, is one of the oldest structures in Brunswick County and is a near-perfect example of Southern antebellum architecture. On April 11, 1973, it was listed in the National Register of Historic Places. The 20 acres of gardens were developed by the Sprunt family. The home, the plantation gardens, and its 5,000 surrounding acres were bought in 2010 by Louis Moore Bacon, a direct descendant of "King" Roger Moore. His plan is to restore the house, Luola's Chapel, the grounds, and the surrounding rice fields. Since it is now

privately owned and closed to the public, the postcard perambulation of it in this book is the best way to see it.

Hollywood has also discovered Orton Plantation, and several movies have been filmed there. The 5,000-acre plantation has much to explore. This book will focus on the gardens, the surrounding woodlands, and old Brunswick Town. Fort Anderson was literally built on top of Brunswick Town. The walls of St. Philip's Anglican Church are still there, and they demand a stop for exploration. The Orton Plantation deeded 114 acres to Fort Anderson and Brunswick Town so the site could be developed.

Long Beach, or Oak Island, is the book's next focus. The island starts at Fort Caswell, at the Cape Fear Inlet and the Frying Pan Shoals, and ends 12.6 miles later at Lockwood's Folly Inlet. Fort Caswell protected the inlet for many years and trained generations of soldiers. It was ultimately sold to the North Carolina Baptist Assembly, which still operates there today. The Oak Island Lighthouse plays heavily in area history and was an early lifesaving station. Hurricane Hazel, in 1954, forced a complete rebuilding; only 15 structures remained, and lots sold in the $350–$500 range. Since then, Oak Island has never looked back. The other end of this mile-wide island ends with a look across Lockwood's Folly Inlet to Holden Beach, opposite Long Bay. Today, recreational opportunities swell the summer population of the island from 15,000 to 30,000 or more.

This book's journey ends on Bald Head Island, a place of colorful people and ecological uniqueness. At one time, former owner Benjamin Smith wanted there to be more wild pigs than people on the island. River pilots watched for ships from a high, barren vantage point they called Bald Head of Land. Old Baldy Lighthouse was built in 1817. Later, the more useful Cape Fear Lighthouse was built. The formerly wild, but still beautiful, island now includes many high-end homes.

# One

# SOUTHPORT

## A PICTURE-PERFECT POSTCARD TOWN

Native Americans saw the beauty of Southport as they gorged on mounds of oysters, Joshua Potts saw it as a gnawingly great dream, and now Hollywood sees it, too. Southporters themselves told many of their stories through the penny postcards seen in this book. Smithville, or "the Fort," received a charter in 1792 and was named in honor of Benjamin Smith, who served under George Washington in the Revolutionary War and became the governor of North Carolina in 1811. The town bore the name until 1887, when it was incorporated as Southport. Some thought this a better name for a town hoping to be chosen as a large seaport; however, Wilmington filled that need instead.

As a quaint example of a little fishing village in small-town America, seemingly untouched by time, Southport drew the eye of Hollywood, and many movies have been filmed there in recent years, including *Crimes of the Heart*, which was filmed in the Sam Northrop house in 1986. Northrop had shot himself during the Depression, and the friendly "Ghost of Sam," his "haint," is said to live on in the house today. This chapter shows the things that make so many fall in love with this unique location.

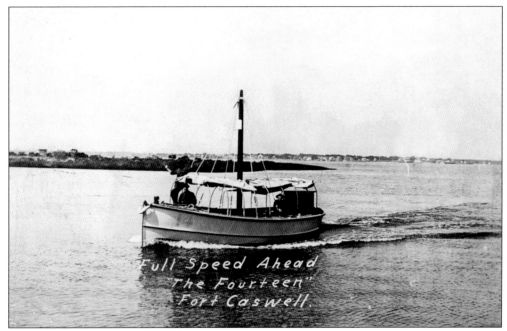

For the last 3,000 years, humans have inhabited the area, and it has always been about the water. This boat, the *Fourteen*, is not fishing; it is actually laying submarine mines from its Fort Caswell home. After the attacks on Pearl Harbor on December 7, 1941, Fort Caswell became a submarine tracking station.

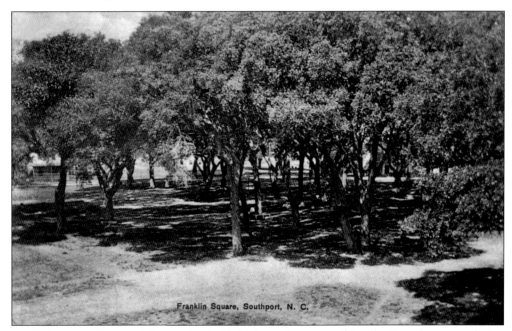

Franklin Square, Southport, N. C.

In 1793, Joshua Potts and Benjamin Smith laid out the town of Smithville. The original plan called for a park, known as Franklin Square, or "the Grove," seen here, on 10 lots designated for town use. The 100 half-acre lots that made up the town did not take long to sell, and a town was born. Lots cost around $4.

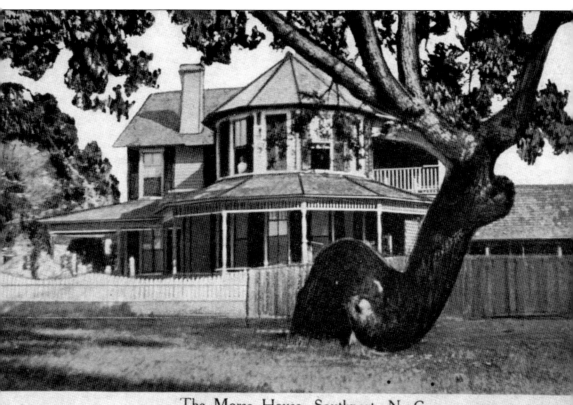

The Morse House, Southport, N. C.

Live oaks are very dense and grow to 60 feet tall with branches over 100 feet long and a base up to seven feet wide. This is the Indian Trail Tree, which marked the trail to the fishing grounds. It is over 800 years old. Mr. and Mrs. C.C. Morse spent 50 years living in this house adjacent to it, dying just days after their golden wedding anniversary. Ah, the stories this tree could tell.

CITY PARK, SOUTHPORT, N. C.

This postcard of the city park shows some of the reused stone border. These stones were used as ballast on incoming ships and then discarded at the shore. They were then recycled into this border; nothing was wasted. Some ballast rocks are hundreds of years old. It took 600 of these beautiful live oaks to lay out the hull of one ship. Few types of wood are stronger.

This early 1900s postcard shows a Southport waterfront view from the pilot's tower, with the quarantine station in the background. The station consisted of a hospital, a disinfecting house, attendants' quarters, and a kitchen. It was built on stilts sunk into the riverbed and is close to the Price's Creek Lighthouse. Nothing remains of the station today, or of anything else in this picture. Hurricane Hazel made a direct hit.

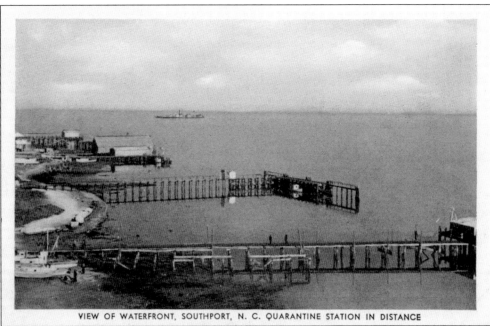

VIEW OF WATERFRONT, SOUTHPORT, N. C. QUARANTINE STATION IN DISTANCE

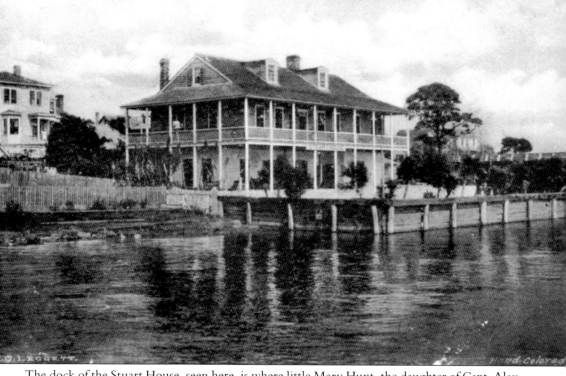

The dock of the Stuart House, seen here, is where little Mary Hunt, the daughter of Capt. Alex Hunt, was saved from drowning. Through the years, guests continued to be drawn to this fine boardinghouse. Rev. Joseph Ruggles Wilson was a frequent visitor from Wilmington. Often, he brought his young son, future president Woodrow Wilson. On another occasion, a young brevet colonel visited: Robert E. Lee. Kate Stuart's majestic Bay Street home was a casualty of Hurricane Hazel. Before that, people from almost every state in America visited. It was tradition to stage the Fourth of July fireworks from the Stuart House pier.

13

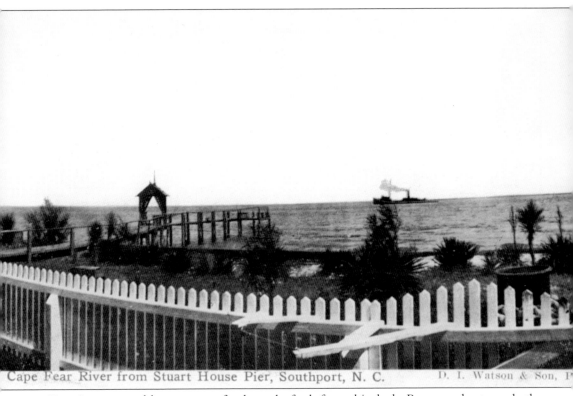

Cape Fear River from Stuart House Pier, Southport, N. C.    D. I. Watson & Son, I'

Kate Stuart served her guests seafood caught fresh from this dock. Passenger boats made the dock a regular stop. Stuart was gracious to all who stayed with her, be they a soldier or a lawyer. Known as the "grand old lady of North Carolina," her peaceful resting place is the Old Smithville Burying Ground. As a special tribute to her, all the ships of the Kyle line, owned by Captain Hunt, would blow a thank-you horn as they passed by the boardinghouse. In response, Stuart would wave a big white handkerchief. It must have been good for business, as more and more visitors made a point of staying there as they began to discover that Southport was much more than just a fishing village. The county seat was located in Southport, but it was later moved due to political pressure.

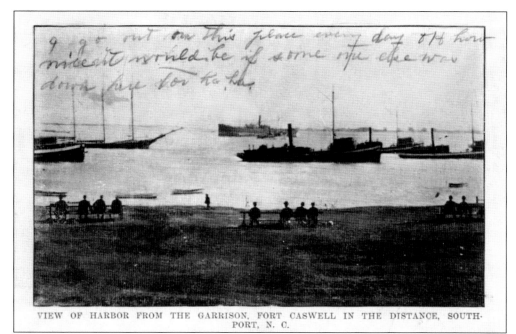

*I go out on this place every day off hour [illegible] would be if some one else was down here for [illegible]*

VIEW OF HARBOR FROM THE GARRISON, FORT CASWELL IN THE DISTANCE, SOUTHPORT, N. C.

These whittling benches are landmarks, although their shade tree no longer stands and they are now in the middle of a parking lot. The benches look across the water with Fort Johnston behind them. Imagine how safe these people must feel sitting between two forts.

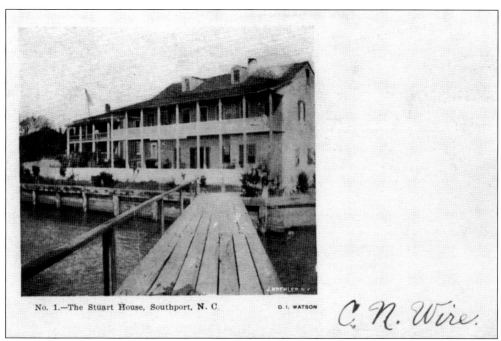

No. 1.—The Stuart House, Southport, N. C.

D. I. WATSON

*C. N. Wire.*

Smithville began with the signing of a charter in 1792. It took a lot of arm-twisting to finally get it the way founders Benjamin Smith and Joshua Potts wanted it. Regular summer visitors soon started coming to the area, sitting on this porch and listening to whistling buoys, among other things.

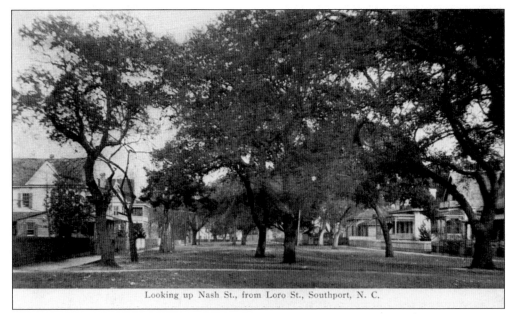

Looking up Nash St., from Loro St., Southport, N. C.

Some of these live oaks still stand today. One beloved tree is in the middle of Nash Street near the Southport Inn Bed & Breakfast. The fire station was adjacent to this tree for years. Note that this postcard misspells Lord Street as Loro Street. William Espey Lord was one of the first commissioners. Within days of his arrival, he pressed for a quick meeting to help form the town.

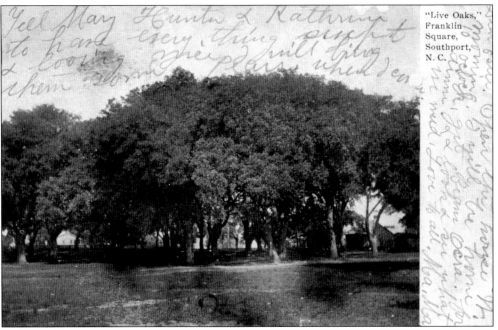

The text above the trees on this postcard reads, "Tell Mary Hunter & Kathryn to have every thing perfect & looking nice," because "MaMa" is coming home. Penny postcards included space for messages on both the front and back.

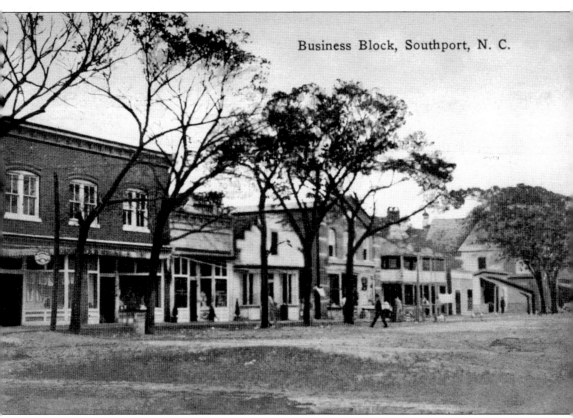

Business Block, Southport, N. C.

Through the years, many people in Southport moved their houses or businesses. The center building in this postcard looks remarkably like the current Shell House. It is one block away from Moore Street on Nash Street. The post office moved multiple times. Living by the maxim "Waste note, want not," and because it is easy to move a house with no basement, many frugal people chose to move their homes and businesses with them. Author Susan Carson finds it almost humorous to follow homes that fit the "used to be there" picture. Her book *Joshua's Dream: A Town With Two Names* is a wonderful walk through the town. There is probably no better portrait of the heart of Southport.

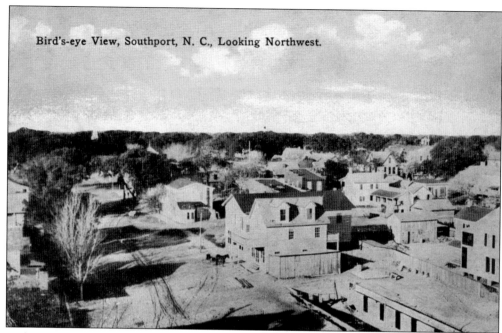

Bird's-eye View, Southport, N. C., Looking Northwest.

Early travelers made good use of the well at Franklin Square, as it produced ample cooling water for the road-weary. Ironically, Dry Street went by it. A trough for the four-legged was attached, but two-legged children also found it a great place to splash. Improved roads soon made travel by road easier.

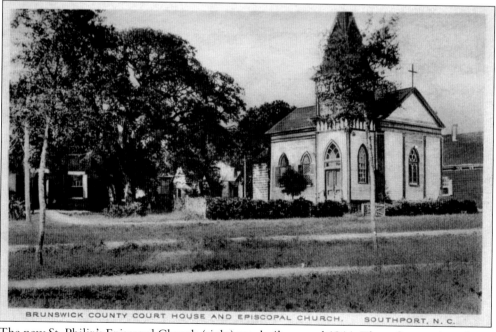

BRUNSWICK COUNTY COURT HOUSE AND EPISCOPAL CHURCH.    SOUTHPORT, N. C.

The new St. Philip's Episcopal Church (right) was built around 1844. Three famous Americans likely worshiped here: Henry Clay in 1844, Daniel Webster in 1847, and John C. Calhoun in 1849. All three certainly visited the Brunswick County Courthouse (left). St. Philip's was used as a hospital in 1865 and later as a school for freed slaves.

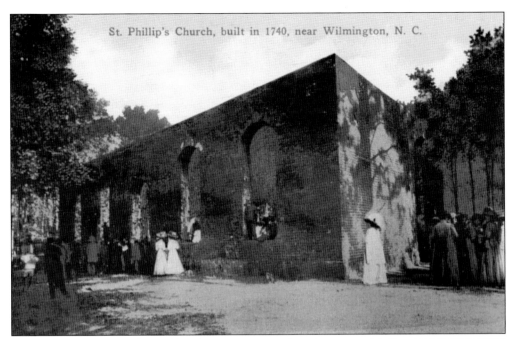

St. Phillip's Church, built in 1740, near Wilmington, N. C.

The old St. Philip's Anglican Church was in Brunswick Town, the capital of the colony. It was started around 1740, and several infusions of money finally brought about its completion in 1768. It was used for just eight years before the British burned it. Its walls can still be seen today, the only remnants of a Colonial church in southeastern North Carolina.

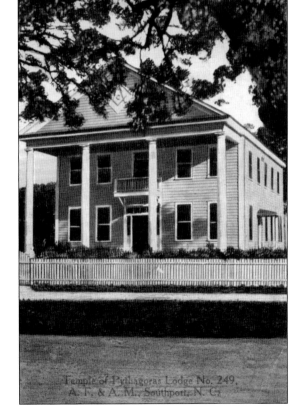

Temple of Pythagoras Lodge No. 249, A. F. & A. M., Southport, N. C.

The Temple of Pythagoras Lodge No. 249, Ancient Free and Accepted Masons, was built in 1872. It was the sixth lodge chartered in North Carolina. Unlike some Masonic lodges today, Pythagoras is experiencing continued growth. A very strong sense of community is evident in its history.

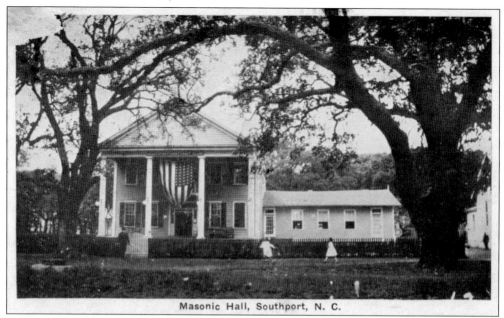

Masonic Hall, Southport, N. C.

The Masonic lodge also served as the Southport Army-Navy Club starting in 1917. Patriotism was running high at that time in America's history. Organizations donated many meals, and there was much music for dancing. Many soldiers and sailors found rest and relaxation at the lodge, which had a bowling alley behind it, near the legendary trees known as the "four sisters." These trees are said to have been planted by a father deeply grieving the untimely deaths of his four young daughters. The deaths are hard to confirm, but no one is willing to question the story. The lodge, not unlike these trees, has been lovingly preserved and is basically unchanged from over 100 years ago.

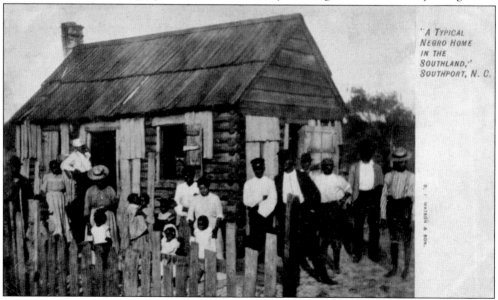

"A TYPICAL NEGRO HOME IN THE SOUTHLAND," SOUTHPORT, N. C.

Life was likely quite hard for those in this Depression-era image. Work was especially sporadic for African Americans. All races practiced a use-it-up, wear-it-out, and make-it-do approach. Families were large, lived in cramped conditions, and did the best they could with what they had. Some rose to high success, including Capt. Eugene Gore, the first black menhaden-fishing captain.

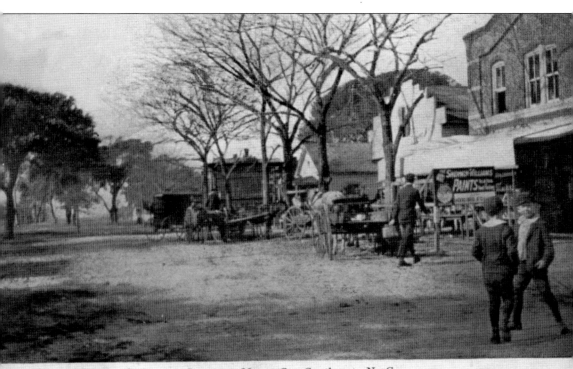

Scene on Moore St., Southport, N. C.

*With line from "Pat"*

This rare postcard shows Moore Street looking west toward Howe Street in 1906. The Sherwin-Williams Paints sign is in front of the Northrop hardware store on Moore Street. The hardware store building still stands and has become one of many Southport antique shops. Most antique shops sell the genuine Southport Pickle Fork. In the spring and summer, men gathered outside the former Loughlin building to discuss business and civic affairs. As the weather grew cool, these discussions moved inside. At the time, Moore Street included two drugstores, several dry goods stores, J.B. Ruark's general store, two law offices, and the post office. The Amuzu Theater and three more grocery stores were on Howe Street.

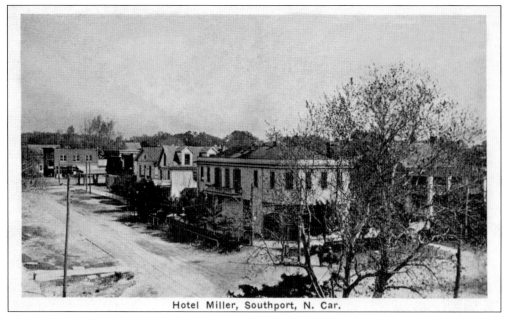

Hotel Miller, Southport, N. Car.

The Hotel Miller was built in the mid–1800s on the northeast corner of Howe and Bay Streets, directly on the waterfront. There were eight bedrooms and a shared bathroom on the second floor. It was a great social center, with a soda fountain and a dining room plus a great harbor view on the first floor. In the late 1930s, Cora Davis & Her Boys were a very popular, lively band that furnished music for Saturday night dances at the Miller. The steamboat *City of Southport* brought passengers to the Miller and other boardinghouses and hotels on Bay Street. The Miller advertised at one point that it now had three bathrooms serving its eight bedrooms. On April 1, 1952, the building was remodeled and reopened as the Miller Café (it later became the Arnold Café). Cherry and lemon Coca-Cola sold for about a nickel, the same price as an ice cream cone.

The Miller Hotel changed names several times to keep up with progress, but its location on the Southport waterfront was very important to its success. The attractive dining room and soda fountain on the first floor encouraged visitors to eat, drink, and enjoy the harbor view. "Meet me at the Miller" would have been understood by most visitors.

BRUNSWICK CO. COURT HOUSE, SOUTHPORT, N.C.

The original Brunswick County Courthouse was transformed into the Southport City Hall in the 1950s. It sits on the corner of Howe and Dry Streets. There is an alley in the middle of the block called I Am. Benjamin Smith bought some original lots for his in-laws, William and Mary Dry, for which Dry Street is named. Southport has a sense of humor: the business block on Moore Street begins with what is known as "Monkey Wrench Corner."

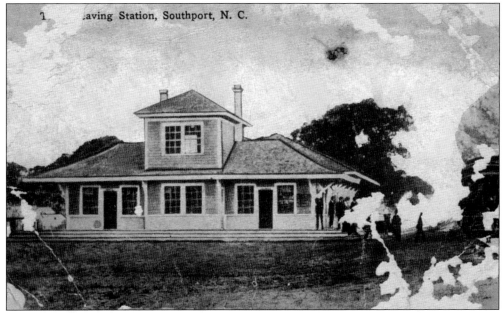

1.    ..aving Station, Southport, N. C.

Trains came to Southport in 1911. The Wilmington, Brunswick & Southern station was on Rhett Street. The trip from Wilmington took two hours and 30 minutes by boat or by train. The railroad was referred to by many as the "Willing But Slow" or the "Wobble, Bump, and Shake." This station burned in 1940, ending train travel to Southport.

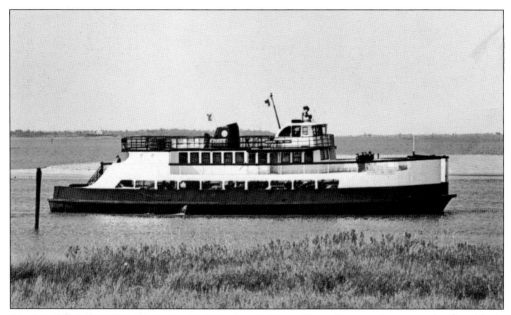

METHODIST CHURCH, SOUTHPORT, N. C.

Capt. Eugene Gore was the first black menhaden-fishing captain. After earning his papers, he was a captain on the Southport–Fort Fisher ferry (pictured). He was a faithful member of the Mt. Carmel African Methodist Episcopal Church, which worshiped in the former Trinity United Methodist Church. The Mt. Carmel congregation moved the old sanctuary to Lord and St. George Streets.

The new Trinity United Methodist Church has two entrances because black and white Methodists often worshiped together but entered and exited through separate doors. Built in 1890, the new church cost $3,300 and was built on one of the 10 lots set aside for city use. The land is forever owned by Southport. The steeple was once damaged by lightning and then restored. Several additions were built through the years. The Mt. Carmel African Methodist Episcopal congregation lovingly and carefully moved the old church down the street to a new home near the Old Smithville Burying Ground. The Gore family played a prominent role in the church.

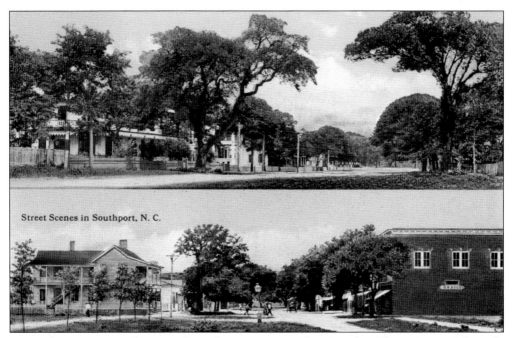

Street Scenes in Southport, N. C.

As Southport progressed, Moore Street began to sprout electric poles. There appears to be only one streetlight in the center of the road. The buildings in the second image are still there today. The one on the left, now the Moore Street Market, is seen in the movie *Safe Haven*.

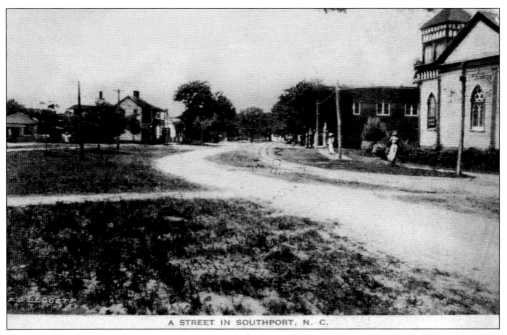

A STREET IN SOUTHPORT, N. C.

The bend in the road on Moore Street is seen here, with the new St. Philip's Episcopal Church on the right. It was finally consecrated in 1860, just in time for another war. The original St. Philip's Anglican Church is now called The Chapel of the Cross. It was the first to celebrate the Fourth of July in Southport, which is now a huge event.

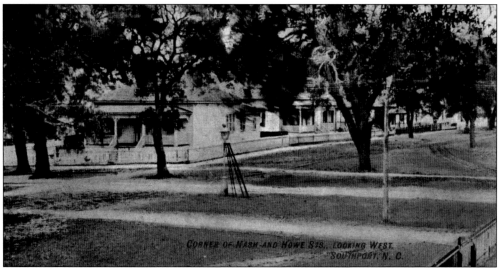

CORNER OF NASH AND HOWE STS. LOOKING WEST. SOUTHPORT, N. C.

This postcard shows another lonesome streetlight, but with a ladder attached to it. One could buy this card at Watson Pharmacy, which is now a restaurant called The Pharmacy. Postage was 1¢. A block away from this scene, on the corner of Nash and Rhett Streets, sits the old jail, which was completed in 1904 and housed prisoners until 1971.

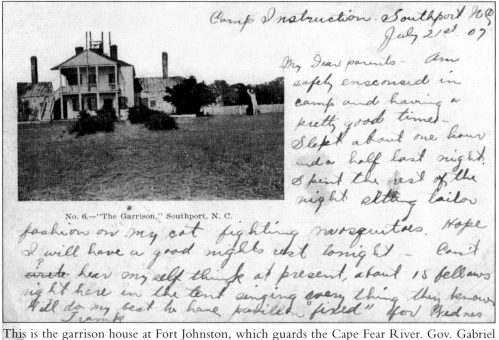

No. 6.—"The Garrison," Southport, N. C.

This is the garrison house at Fort Johnston, which guards the Cape Fear River. Gov. Gabriel Johnston became very concerned when France joined Spain in siding against England in 1744, as the Colony of North Carolina needed to be protected for England. Johnston's fort was proposed at that time, but politics slowed the action, allowing Spanish privateers to attempt capture of the uncompleted fort. They were not successful, but they did loot Brunswick Town. Rumor has it that they drank the wine and enjoyed the tobacco of the townspeople and then moved on. The fort was finally complete in 1749, just in time to miss the Spanish and French challenge to England for which it was built.

Brunswick Street, also known as Lover's Lane, wraps around the old boat harbor and connects to the river walk. A private place to stroll with one's sweetheart, Southport history could also be witnessed there by viewing the bicentennial quilt, created in 1992 by the Southport Historical Society. It hangs today inside the Fort Johnston Visitors Center and features 30 squares.

Fort Johnston has gone through times of neglect and has also been the center of great conflict. When the American Revolution broke out, North Carolina governor Josiah Martin fled from New Bern to Fort Johnston in an attempt to avoid being kidnapped. The colony's seat of government was then transferred to this tiny fort. It became a "little Raleigh on the river." Martin was very unwelcome, however; in a month, he fled again to a waiting British ship. Rebels then burned the fort as a symbol of British tyranny. After that, George Washington stepped in, demanding the rebuilding of the fort. In 1795, Southport citizens enjoyed their first documented Fourth of July celebration.

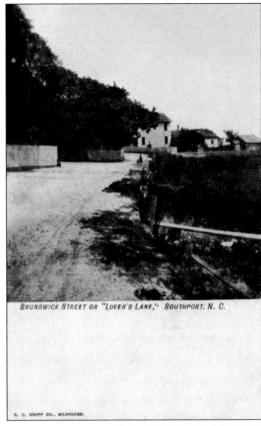

BRUNSWICK STREET OR "LOVER'S LANE," SOUTHPORT, N. C.

S. C. KROPP CO., MILWAUKEE.

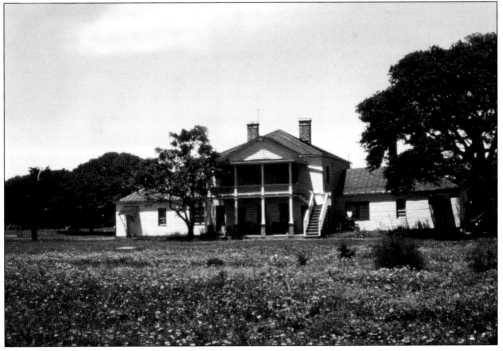

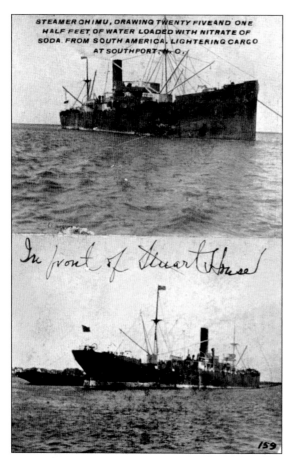

STEAMER OHIMU, DRAWING TWENTY FIVE AND ONE HALF FEET OF WATER LOADED WITH NITRATE OF SODA, FROM SOUTH AMERICA, LIGHTERING CARGO AT SOUTHPORT, N. C.

In front of Stuart House

159

The steamer *Ohimu* used the Stuart House dock for "lightering," or offloading cargo to a smaller ship. The boat's 26-foot draft prohibited it from passing the Frying Pan Shoals and the even shallower water upstream, so Wilmington could not be its destination. Today, dredging would make this possible.

This photograph from an early Fort Caswell dock looks back at Southport, with the water tower in the left distance. Over the years, many river pilots drowned attempting to swim between the fort and Southport. A monument was erected in town to those who drowned in the line of duty. Many are buried in the Old Smithville Burying Ground, which was founded in 1792.

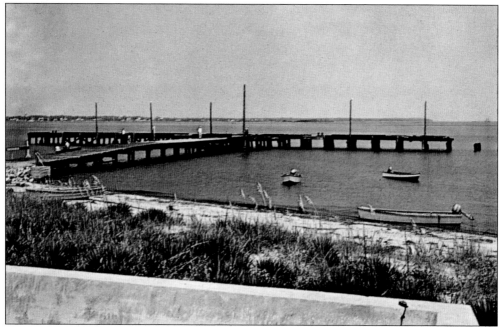

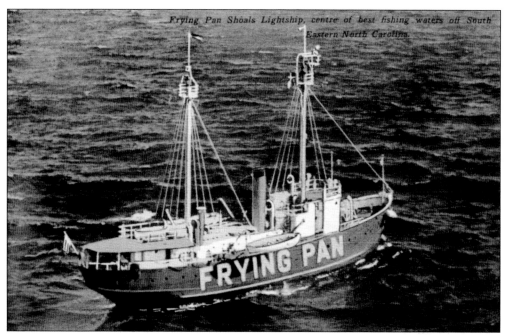

Beginning in 1854, the Frying Pan Shoals Lightship was anchored at the very beginning of these dangerous shoals. This ship was the last one to light the way. Its 13,000-candlepower light was replaced by what is known as a Texas Tower in 1964, which produces 3.5 million candlepower and is visible from 17 miles or more. This ship still lives on today.

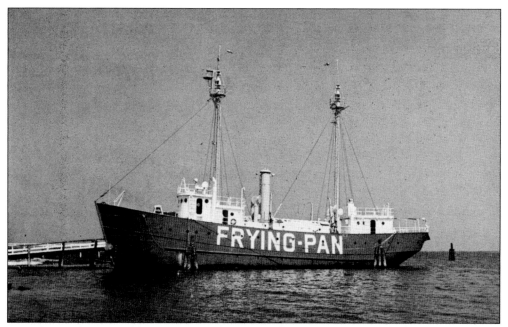

An attempt was made to create a floating museum in Southport on the Frying Pan Shoals Lightship. However, it eventually found a home in Baltimore Harbor. It had required a crew of 16, as well as constant maintenance. Today, it is a privately owned party boat used for community theater and a variety of parties. The empty engine room makes a great floor for dancing.

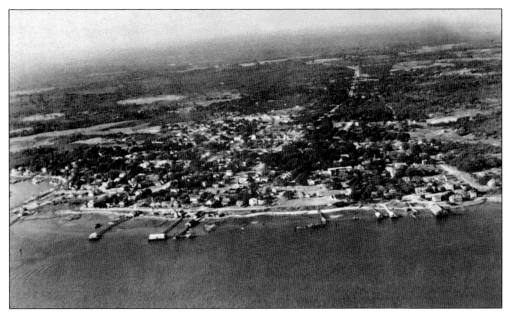

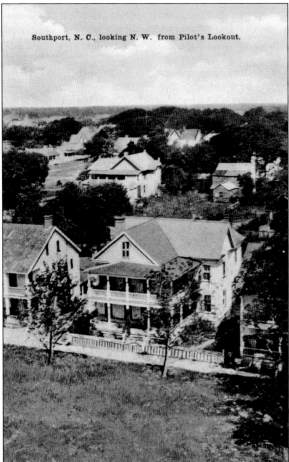

Southport, N. C., looking N. W. from Pilot's Lookout.

This aerial view shows a bustling Southport, when shrimp and menhaden were Southport gold. Before shrimp was put on a table, a boat dragged trawler nets on long booms and then either salted the catch or iced it for rapid shipment to markets up and down the East Coast. Originally, "big shrimp" sold for $3 per bushel.

Homes like this Southport gem were built on lots that had million-dollar views but were relatively cheap. Capt. Tommy Thompson built his house nearby with his blockade-running earnings. He paid $495 for two lots at auction in 1867. They were lots No. 1 and 2 of the original 100. This is the Richard Dosher home, built in 1893.

The fishing was great in the early days, as this mullet catch proves. The Gulf Stream, not far away, was the home of this elegant swordfish. Before Hurricane Hazel in 1954, the area had peak-production years for all kinds of fishing. During fishing season, from May to December, up to 300 boats would usually unload phenomenal catches.

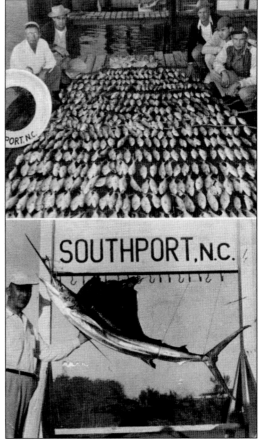

This postcard shows more mullet than the nets can hold. The largest row mullet catch ever recorded was in 1915. The 35,000 fish were worth $1,200. Today, only about nine boats remain, mostly catching shrimp, predominantly brown shrimp. The boats are easily identified by the flocks of seabirds surrounding them.

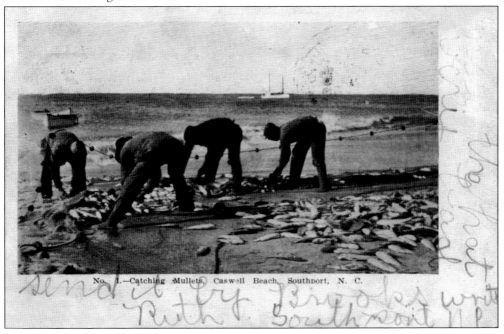

No. 1.—Catching Mullets, Caswell Beach, Southport, N. C.

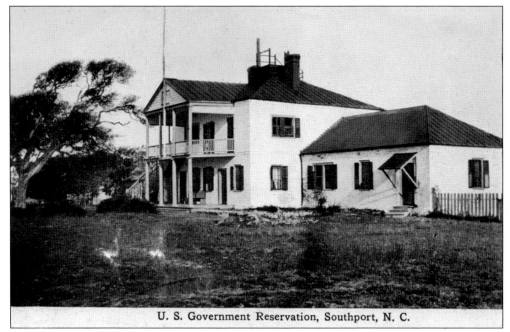

U. S. Government Reservation, Southport, N. C.

This is one of the last buildings remaining at Fort Johnston. Its construction began around 1804 and it was "not quite finished" for many years. This is the way the officers' quarters would have looked in 1861. At that time, the fort was used as a recruiting, training, and supply center. It was central to the Cape Fear defense system from 1861 to 1865.

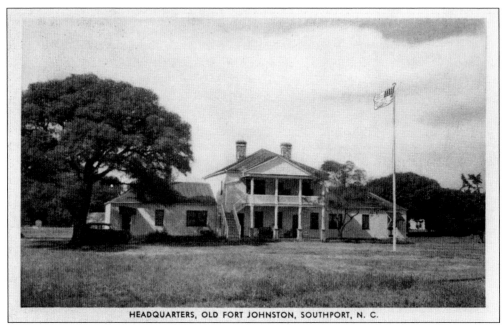

HEADQUARTERS, OLD FORT JOHNSTON, SOUTHPORT, N. C.

This is how Fort Johnston looked in 1865, when its lovingly made Confederate flag was lowered and replaced by the American flag. Fort Fisher had fallen, and the weary soldiers of Fort Caswell and Fort Johnston trudged on to their next stand at Fort Anderson. Union Navy lieutenant William B. Cushing became the military governor of Smithville.

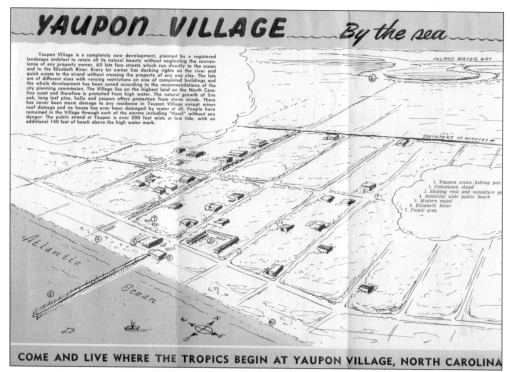

## YAUPON VILLAGE — By the sea

Yaupon Village is a completely new development, planned by a registered landscape architect to retain all its natural beauty without neglecting the convenience of any property owner. All lots face streets which run directly to the ocean and to the Elizabeth River. Every lot owner has docking rights on the river and quick access to the strand without crossing the property of any one else. The lots are of different sizes with varying restrictions on size of completed buildings and the whole development has been zoned according to the recommendations of the city planning commission. The Village lies on the highest land on the North Carolina coast and therefore is protected from high water. The natural growth of live oak, long leaf pine, holly and yaupon offers protection from storm winds. There has never been storm damage to any residence in Yaupon Village except minor roof damage and no house has ever been damaged by water at all. People have remained in the Village through each of the storms including "Hazel" without any danger. The public strand at Yaupon is over 200 feet wide at low tide, with an additional 140 feet of beach above the high water mark.

INLAND WATER WAY

SOUTHPORT 10 MINUTES

1. Yaupon ocean fishing pier
2. Concession stand
3. Skating rink and miniature golf
4. Beautiful wide public beach
5. Modern motel
6. Elizabeth River
7. Picnic area

Atlantic

Ocean

**COME AND LIVE WHERE THE TROPICS BEGIN AT YAUPON VILLAGE, NORTH CAROLINA**

Barbees Incorporated Developers touted Yaupon village as the newest and best ocean-side community available in 1960. Hurricane Hazel, in October 1954, had swept the entire island clean. Everything would be new and of the client's choosing. When visiting, one could fish from a charter boat or from the pier, play miniature golf, or go roller-skating. Lodging included a modern motel, and there was a choice of several restaurants. During their stay, it was hoped that visitors would remain and ask Barbees to build their home. This was the first attempt to encourage rebuilders or newcomers to build outside Southport.

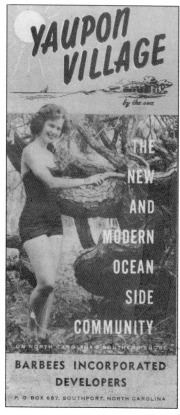

YAUPON VILLAGE
by the sea

THE NEW AND MODERN OCEAN SIDE COMMUNITY
ON NORTH CAROLINA'S SOUTHERN COAST

BARBEES INCORPORATED
DEVELOPERS

P. O. BOX 687, SOUTHPORT, NORTH CAROLINA

33

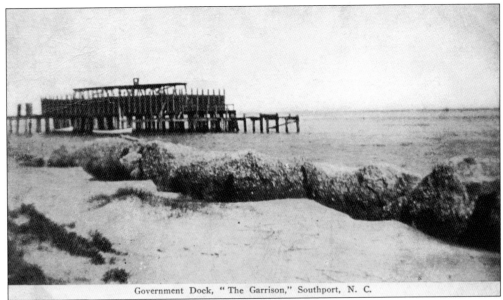

Government Dock, "The Garrison," Southport, N. C.

What looks like rocks in this postcard is actually tapia, or tabby. This mixture of lime, oyster shell, and sand was the cement of the time. It was not very strong. The government dock on the left was used as a safe place to swim. The dock was small, with a diving board and a float. It was roped off for safety and dubbed "Little Coney."

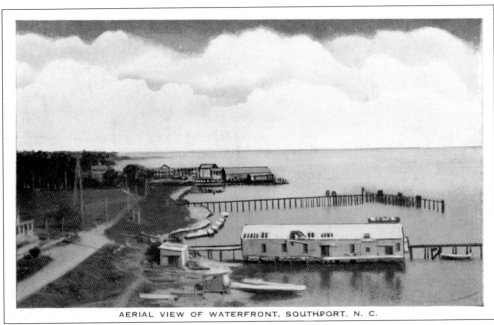

AERIAL VIEW OF WATERFRONT, SOUTHPORT, N. C.

Little Coney is seen here in the foreground, and the group of buildings in the background includes the pavilion. The heyday of this happening place in Southport seems to have been around World War II. The cupola was a great vantage point.

## *Fishing Fleet*

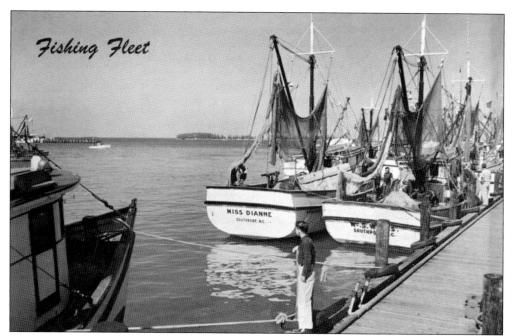

Members of the shrimp fleet are seen here. These trawl nets, with booms, or arms, extending from both sides of the boat, collect "big shrimp" as they are hauled through the water. All nets have a turtle extruder device, or TED. Shrimp once sold for $3 per bushel, and then became more profitable to sell for 30¢ per pound.

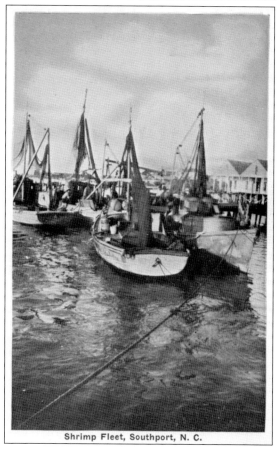

Hurricane Hazel changed everything seen in this image. The boats, docks, and packinghouses were all destroyed. In 1919, the industry sent about 30 railcars per season of fresh iced or salted shrimp all over America. Much local shrimp went to New York City and the Fulton Fish Market. Southport's brown shrimp were prized, and eight-inch shrimp were common.

**Shrimp Fleet, Southport, N. C.**

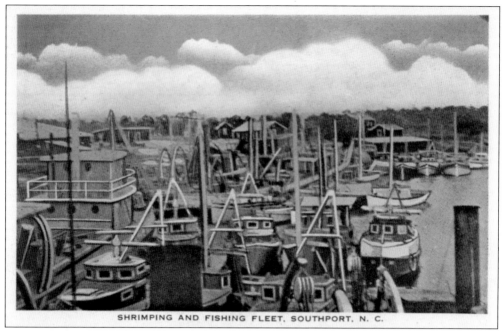

SHRIMPING AND FISHING FLEET, SOUTHPORT, N. C.

This rare painted postcard shows many menhaden boats. No market exists today for this oily, smelly, inedible fish. However, the industry brought steady employment to this area for many years. Some called it Southport Gold. Pollution and overfishing were both causes of its decline.

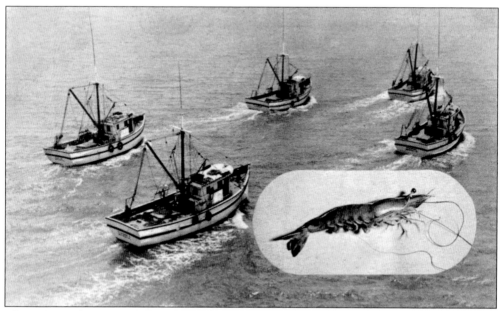

These shrimp boats trawled all night for the tasty crustaceans, which were once used only as bait. Elias "Nehi" Gore was known as the gentle giant of commercial fishermen. He was seven feet, six inches tall. He dropped out of school to support his family as a fisherman, demanding that his siblings get an education. Everyone loved Nehi, and he is honored in the Maritime Museum of Southport.

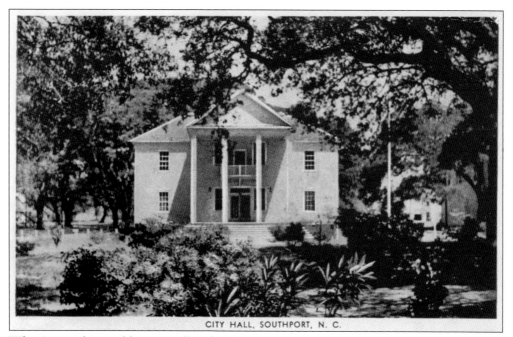

CITY HALL, SOUTHPORT, N. C.

What is now the Franklin Art Gallery has had quite a past. The building has served as a school, a community center, a library, and even city hall.

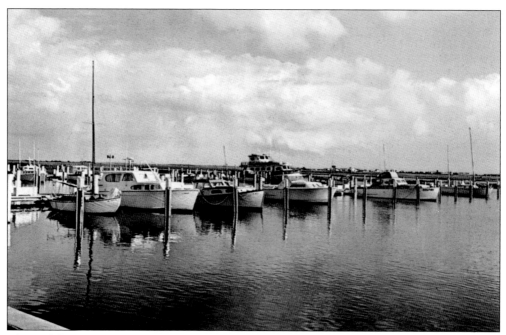

The "salubrious breezes" that Joshua Potts noted are a sailor's delight. Many sailors credit the "rocks" installed to further protect the new inlet with providing them a great basin in which to sail. The Provision Company, whose dock is seen here, is a favorite "sail-in" dining spot.

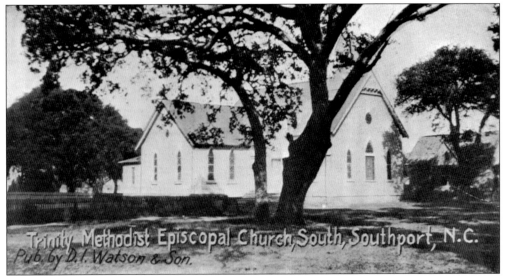

Trinity Methodist Episcopal Church, South, Southport, N.C.
Pub. by D.I. Watson & Son.

The congregation of the Methodist church and the Methodist Conference voted unanimously in 1888 to construct a new church within two years. According to Carl Lounsbury's *The Architecture of Southport*, a Mr. Fore and a Mr. Foster of Wilmington designed and made the beautiful stained glass for the lancet windows. Highly polished Carolina pine covers the interior. A 28-year-old shipbuilder named Henry Daniel directed the construction. The sanctuary, completed in May 1890, has been modernized many times since, but nothing has changed its Victorian style. The bell still chimes the service and has never been motorized. It is now known as Trinity United Methodist Church.

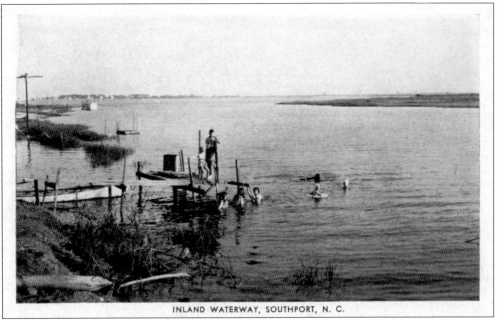

INLAND WATERWAY, SOUTHPORT, N. C.

In answer to safety and travel-time concerns about traveling up and down the East Coast by boat, the Intracoastal Waterway was built through Southport in 1931. This section was to be 33 miles long, going from Southport to Little River. The depth was to be grubbed to nine feet by both man and machine. The causeway cut for the waterway made it impossible to visit Fort Caswell or Caswell Beach except by boat.

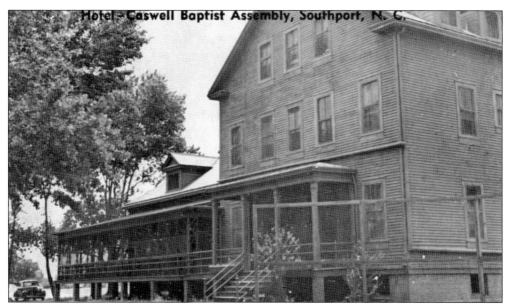

This was a hospital run by the Caswell Baptist Assembly in early 1900 before it became a hotel. Notice the open-air porches, allowing patients to enjoy healthy ocean breezes. It was thought that this was "curative" to almost anything that might ail a person. Just the pleasant surroundings may have helped.

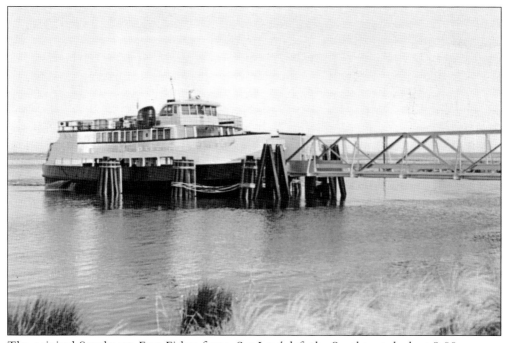

The original Southport–Fort Fisher ferry, *Sea Level*, left the Southport dock at 9:00 a.m. on February 8, 1966, with nine cars. The trip is four miles and takes 20–30 minutes. In the 1980s, traffic increases necessitated the running of two ferries. Today, over 313,000 people use this water route annually. The new ferries carry 34 cars and up to 300 passengers.

NIGHT VIEW OF BALD HEAD ISLAND, SOUTHPORT, N. C.

The scenic Southport–Fort Fisher ferry ride passes Prices Creek Lighthouse and "Old Baldy," while Oak Island Lighthouse looms in the far distance on the right. The ferry often shares the channel with large container ships and watercraft from all over the world. Waterbirds abound on the small islands nearby, including pelicans, egrets, and gulls.

As the ferry leaves Fort Fisher on Federal Point, the yellow cranes of the Sunny Point Army munitions terminal are visible. To the left is the "battery mound" of Civil War times, which was the last to fall at the surrender of Fort Fisher. In March 1966, the ferry symbolically pulled together both sides of the Cape Fear River.

40

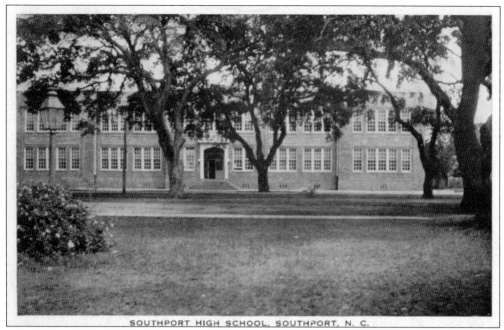

SOUTHPORT HIGH SCHOOL, SOUTHPORT, N. C.

Southport High School was state-of-the-art when it was built in 1923. Its spacious auditorium was the only one in the county for a long time. The area's first motorized fire engine arrived that same year. The 1923 Ford Model T and the original fire bell are carefully preserved and weather-protected next to the new fire station.

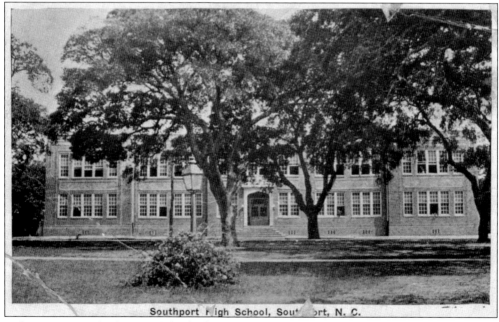

Southport High School, Southport, N. C.

A fire mysteriously destroyed the high school in 1969. Classes were then held at Brunswick County Training School, which was originally a school for black students. The original school bell is in front of the present post office. It says, "Site of the Southport High School – home of the dolphins – built in 1922 – destroyed in January 1969."

41

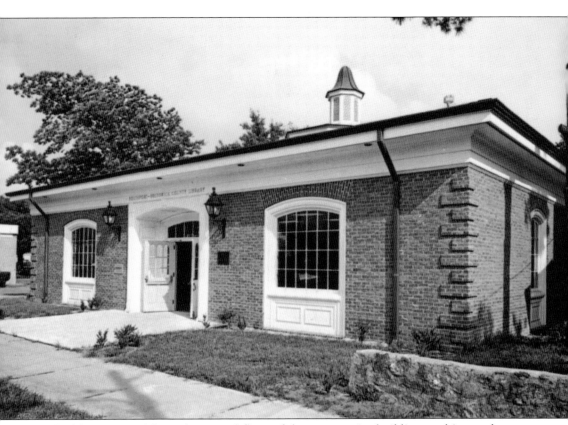

The library moved from the second floor of the community building to this new home on Moore Street in 1995. Among the many books transferred were 100 that came in a tea chest from Southport's sister city, Southport, England. In 1912, Gertrude Loughlin checked out the first book, *Rebecca of Sunny Brook Farm*. In December 2002 the library was named the Margaret and James Harper Jr. Library.

Southport proudly sported eight miles of "good roads" heading toward Wilmington in 1916. The post office was on South Howe Street before moving to Moore Street. It then moved to the other side of Moore Street, within the same block. The post office moved no more and is still on East Nash Street across from the Masonic Lodge and Trinity United Methodist Church.

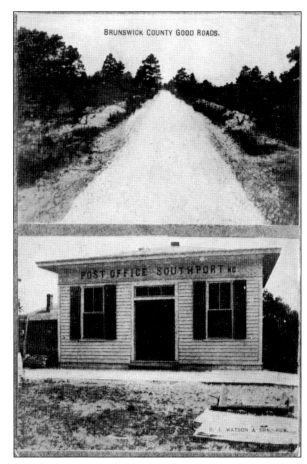

The only remaining motel on the Southport waterfront is next to the Southport river pilot watchtower, on the left. Pilots are on call 24 hours a day, seven days a week. The licensing and training are intense for a three-year period. They must be able to pilot any size ship, understand personnel from any country, and read the dashboard of any ship.

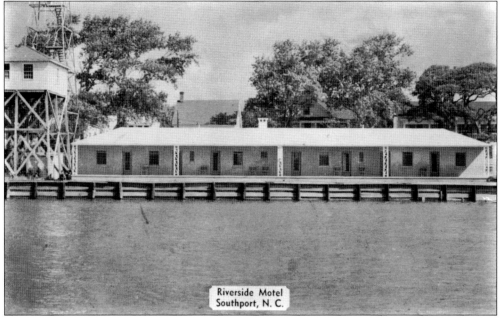

Riverside Motel
Southport, N. C.

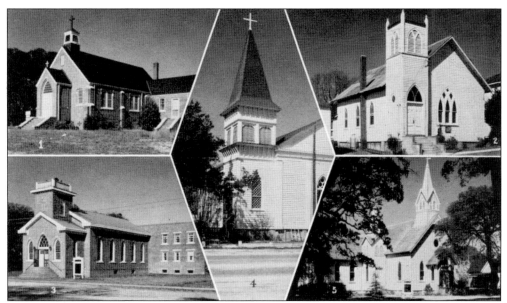

This composite postcard shows some of the churches of Southport. Sacred Heart Catholic Church (1) is now a lovingly remodeled private home. The new owners saved the bell, which still works. Southport Presbyterian Church (2) is no longer standing, but it made generations of youths happy with a hillside setting that was perfect for sliding and skating. Southport Baptist Church (3) is now the cheerful chapel of a much larger church. The "new" St. Philip's Episcopal Church (4) lives on basically unchanged from when it was built in 1844. The "new" Trinity United Methodist Church (5) was completed in 1890, while the old Trinity sanctuary was moved by Mt. Carmel African Methodist Episcopal Church to Lord and St. George Streets. On any given Sunday, the bells of these churches still make joyful noise all over Southport.

Beautiful Southport Baptist Church, seen here along with its parsonage, began as Smithville Baptist Church in 1871. A significant donor, the John W. Wescott family, provided the majority of funds for a new church 20 years ago. The old bell still exists.

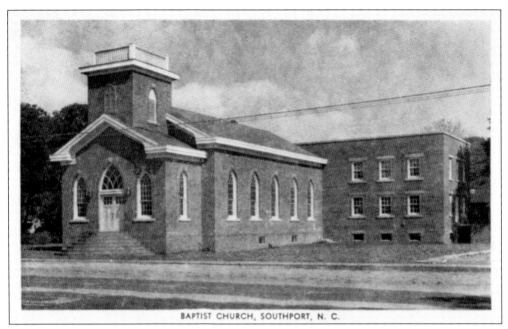

BAPTIST CHURCH, SOUTHPORT, N. C.

What happened to that church on Nash Street? It was moved, covered in brick, lost its steeple, and was turned 90 degrees. It is now the beautiful Baptist chapel on the corner of Nash and Howe Streets. The education building at right was a later addition.

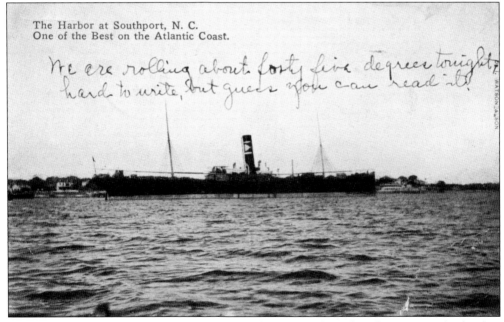

The Harbor at Southport, N. C.
One of the Best on the Atlantic Coast.

*We are rolling about forty five degrees tonight; hard to write, but guess you can read it.*

The sender of this postcard wrote, "We are rolling about forty five degrees tonight; hard to write, but guess you can read it." Thankfully, the ship found safe harbor, as it is the only one for many miles. There were many storms in Southport before Hurricane Hazel hit in 1954. One 1893 storm brought 94-mile-per-hour winds and a water overflow exceeding 19 inches. Much wreckage followed. Those were the highest recorded winds to that date.

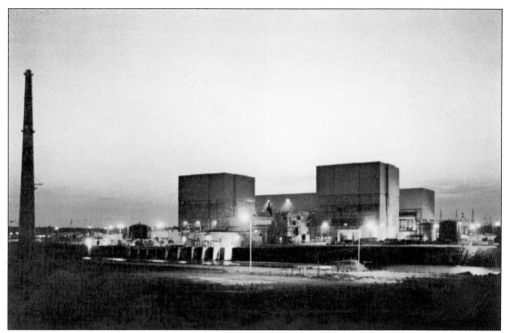

The Brunswick nuclear power plant changed Southport forever. It is a huge economic boon to the area and a wise choice of affordable power for many years to come. The two boiling water reactors provide enough power to serve well above 350,000 homes. Careful monitoring keeps it safe and friendly to the environment.

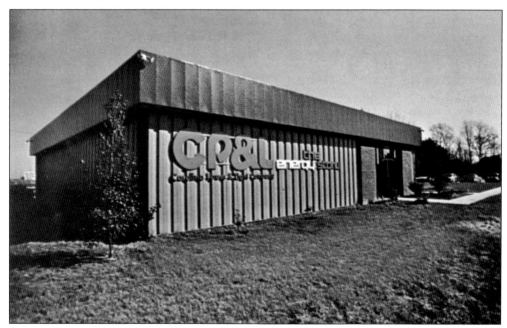

Carolina Power & Light operates this visitor center to inform and educate all who are interested in the plant. The needed water is drawn from the Cape Fear River through a 2.5-mile intake canal. The exit route is 5.5 miles long, allowing slightly warm water to flow under the Intracoastal Waterway and discharge well out to sea.

This community center is part of the Carolina Power & Light offices. Civic meetings are frequently held here. Uranium pellets are about the size of a half-inch-long piece of chalk and produce the same energy as three quarters of a ton of coal. To produce the same amount of energy, this plant would have to use over 156 railroad cars of coal per day.

This replica of a six-pound bronze cannon was made in Coolville, Ohio, for Robert DeHaven. It was generously donated to the Southport Historical Society in 2001. A sharp eye can see it in the movie *Gods and Generals*.

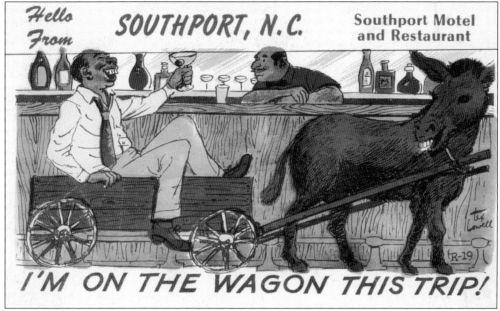

This whimsical card from the Southport Motel & Restaurant includes a nod to the wagons that brought many Southport settlers down the Great Wagon Road from Pennsylvania.

Seen here are, clockwise from the top left, Trinity United Methodist Church, the Frying Pan Shoals Lightship, the garrison house at Fort Johnston, and, finally, the Southport fishing fleet seen through a shrimp net.

Boiling Springs is an artesian spring near Orton Plantation that produces 43 million gallons of water per day. There seem to be great prospects for industrial development at the site. The spring's fabulous water flow has not gone unnoticed by the North Carolina Department of Development. It is slightly up the road from Southport and was thought a great site to turn sleepy Southport into suburbia.

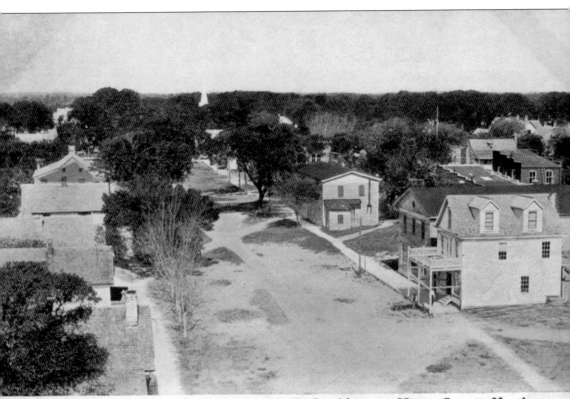

**Bird's-eye View of Southport, N. C. Looking up Howe Street, North.**

This postcard, taken from the old pilot tower at the foot of Howe Street, is a favorite of many, showcasing Southport's beloved live oaks. Sadly, most of the trees in this image are gone today. "Pack" Tharp's barbershop, in the right foreground, was a great place to catch up on the town news.

# Two

# Orton Plantation, Fort Anderson, and Brunswick Town

## Azaleas and Bullets

Following River Road three miles north from Boiling Springs brings one to Orton Plantation. The 1735 mansion was built in the Classical Revival and Greek Revival styles. Of the plantation's 5,000 acres, 20 have been transformed into carefully planned, spectacular gardens. The gardens celebrated their 100th anniversary in 2010. There are another 60 acres of old rice fields, statues, and inviting lagoons. A dirt driveway lined with 300-year-old live oak trees leads to the mansion. The near-perfect example of Southern antebellum architecture was listed in the National Register of Historic Places on April 11, 1973.

The builder of the mansion, "King" Roger Moore, eventually sold Orton to Benjamin Smith, the cofounder of Smithville, who lost ownership through a bad business decision. Starting in 1884, the Murchison and Sprunt families owned Orton for 126 years, until 2010. They added to the gardens and built Luola Chapel. They also graciously donated 114 acres to establish the Brunswick Town State Historical Site. In 2010, Orton was sold to a direct descendant of "King" Roger Moore, Louis Moore Bacon, who then closed the plantation to the public in order to execute extensive renovations and preserve it in a more natural state.

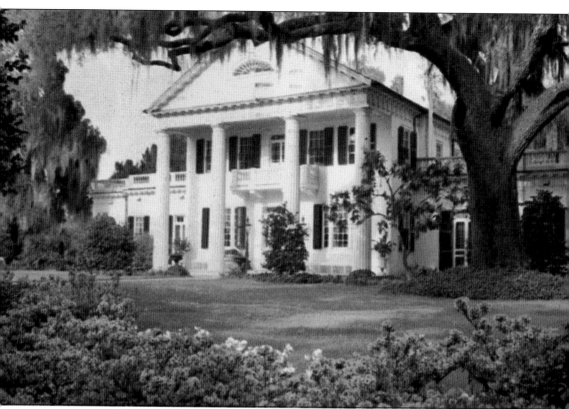

This is Orton Mansion. The gardens are ablaze with colorful azaleas, camellias, seasonal flowers, and live oaks during the spring, summer, and fall. Admission to the plantation was $1.25 in 1949. *The State* magazine declared Orton the most beautiful spot in all of eastern North Carolina. It is ranked as the second-most interesting tourist attraction in the state, after the Wright Memorial. Treasure keeps coming to the surface in the area; as late as 1950, two gold-hilted Revolutionary-period swords were uncovered when the new section of River Road was being built.

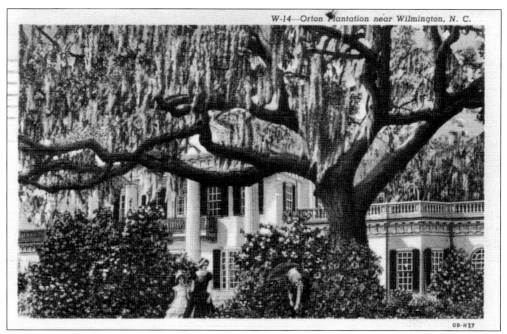

The live oak tree and the period clothing seem central to this handsome painted postcard. The Spanish moss hanging from the tree is an epiphyte. It gets all the nutrients it needs from the air and just uses the tree for support. The beautiful flowers of the grounds dwarf the people in this postcard.

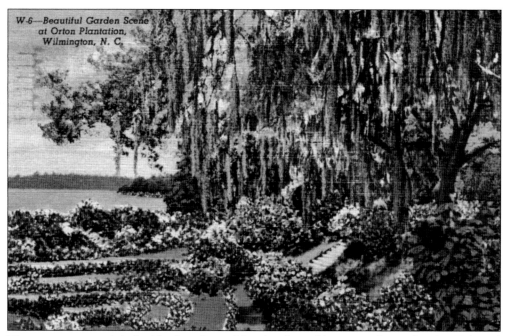

W-6—Beautiful Garden Scene at Orton Plantation, Wilmington, N. C.

The steps at center right lead back to Orton Mansion from this spectacular garden site. Talented gardeners have turned this former rice field into what it is today. The mundane has become candy for the eye, with the Cape Fear River providing the vista.

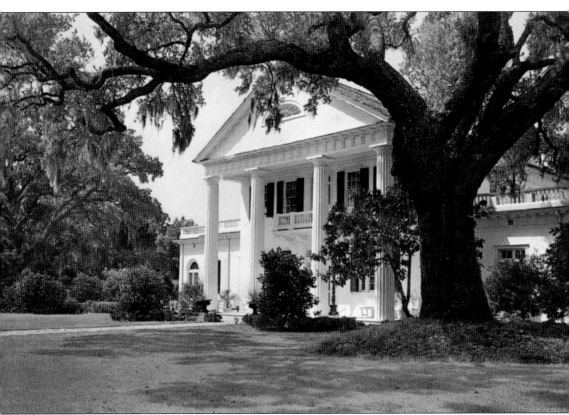

The front of the mansion looks out on the Cape Fear River and has done so since 1735. Orton has seen quite a lot in its nearly 300 years, including an invasion by British troops during the Revolution and blockade runners by the score. A sad day happened when Orton witnessed the fall of Fort Fisher. The style and design of Orton Mansion continues to be influential today. Orton is in the buffer zone of the Sunny Point ammunition depot, which is just off the newly paved Highway 133.

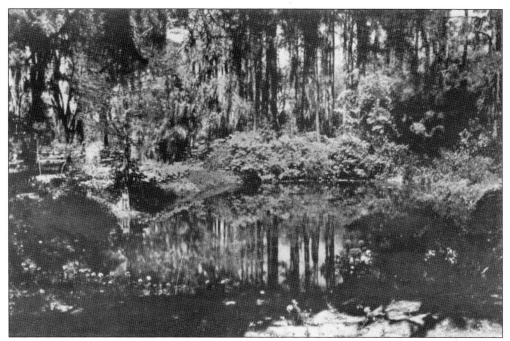

Orton has up to 140 acres of mixed forest, and ponds are spotted around the plantation. There are surprises at every turn. During the Civil War, one Orton pond was the end of a defense line from Fort Anderson to stop overland attack up the west side of the river.

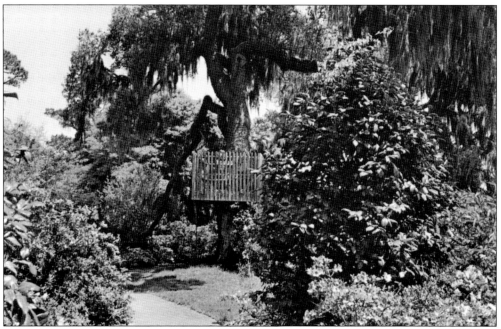

This image, showcasing these magnolias, shows a place in the tree to do some birding and enjoy the gardens from up high. The moss-covered tree provides ample shade and those famous "salubrious breezes" on hot and humid summer days.

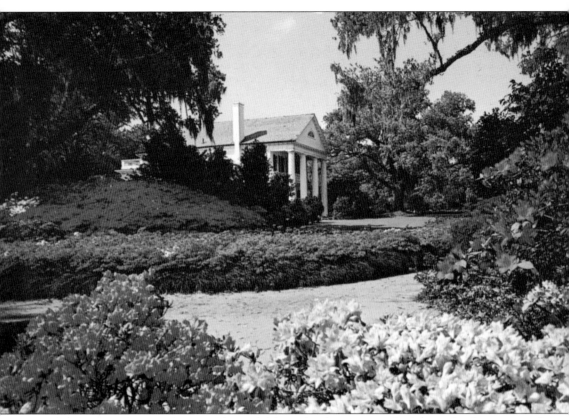

The photographer stood in an old rice field to take this image. The Sprunt family, owners of Orton from 1884 to 2010, collected and planted many of the existing azalea varieties. Orton now has a collection of several hundred azaleas, one of the most complete collections in America.

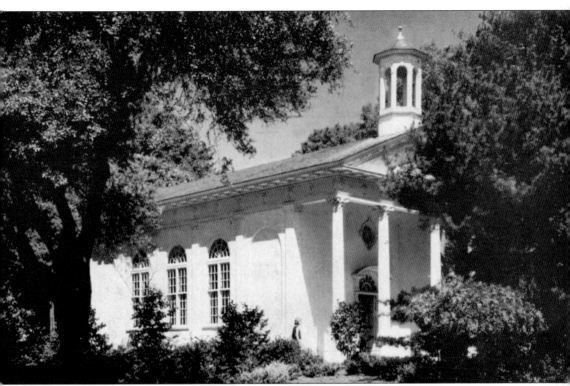

Seen here is Luola's Chapel, built in 1915 next to Orton Mansion. A year later, after James Sprunt's young, lovely wife, Luola, was a victim of scarlet fever, he renamed it in honor of her. They were deeply in love, and his life was never again completely whole. Just stepping inside this holy place makes one feel a great peace. James and Luola Sprunt added the wings to Orton in 1910. They then began adding the gardens seen here. The outstanding chapel hosted family services, as travel to distant parishes was difficult. The name Luola can still be seen etched into the stained-glass windows. James Sprunt, who owned the largest cotton export company in the world, financed the construction of many more churches.

This is just one of many paths around the gardens at Orton Plantation. All of the other Cape Fear plantations of long ago are gone except Orton, which survives in floral splendor as one of the most beautiful homes in America. After James Sprunt's death in 1924, his son James Laurence Sprunt and his wife, Annie Gray, extended the gardens and the path to Roger Moore's graveyard. In the 1930s and 1940s, they planted azaleas, camellias, flowered peaches, daphnes, hydrangeas, crepe myrtles, dogwoods, and many colorful annuals. Churchill Bragaw contributed greatly to the garden planning and building. He was killed in World War II. A dormitory was named in his memory at North Carolina State in Raleigh, where he received his degree in horticulture.

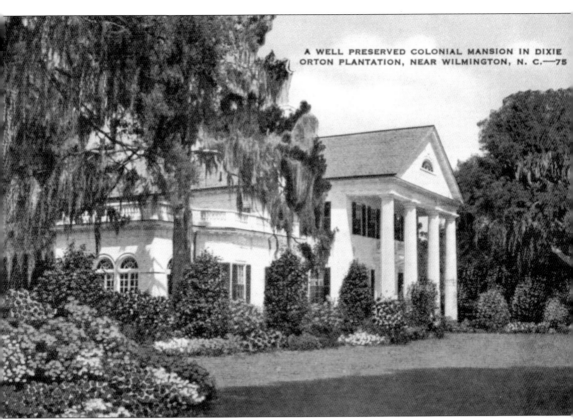

This printed and painted postcard shows one addition to the main house. There is a duplicate on the other side. "King" Roger Moore's grandson was Benjamin Smith of Smithville, Belvedere Plantation, and Orton Plantation. He inherited wealth and married well. His wife, Sarah Dry, was the heiress of William Dry's estate. Smith also owned Bald Head Island and 20,000 acres in Tennessee, which he later gave to the University of North Carolina. As an act of gratitude, Smith Hall at the university is named for him.

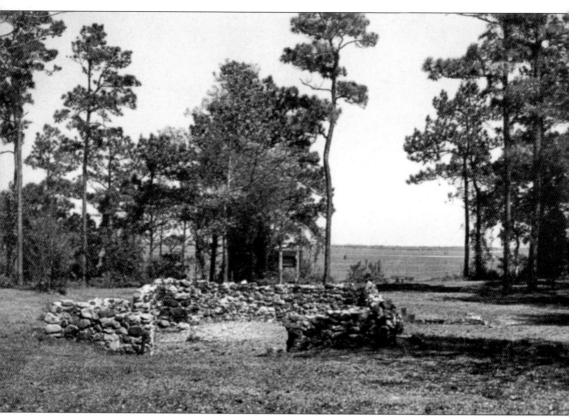

Just a short way from Orton is Old Brunswick Town, the remains of which look the same today as they do in this postcard. Nathaniel Moore's home is labeled "Nath Moore's Front" on the sign in the background. It overlooks the river on the corner of Front and Cross Streets. Coins, a wig curler, and lead bale clips that were used on imported bolts of cloth were found during excavation.

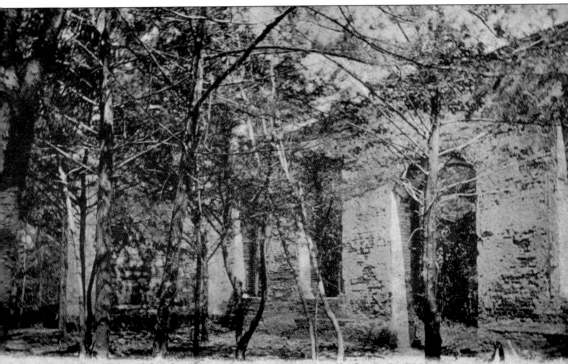

Ruins of Old St. Philip's Church at Brunswick, N. C.  Built 1724
The Town once the Capital of the Colony has disappeared, save this Ruin and the  Churchyard

The most prominent ruin in Brunswick Town is St. Philip's Anglican Church. Construction began in 1724, but it was built over time and was not finished until 1768. After that, it was only used for eight years before the British sacked and burned the church and the nearly deserted town. The three-foot-thick walls survived Union shelling in 1865 and remain to this day.

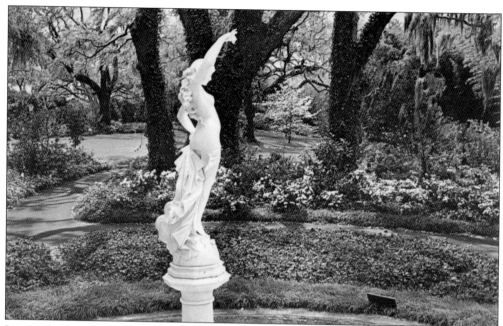

In a sunken section of the gardens at Orton is the sculpture *Spring Star*, created by the noted Italian sculptor Ferdinando Andreini. It is the centerpiece of this carefully designed grotto. The flowers selected for the area are exclusively white azaleas.

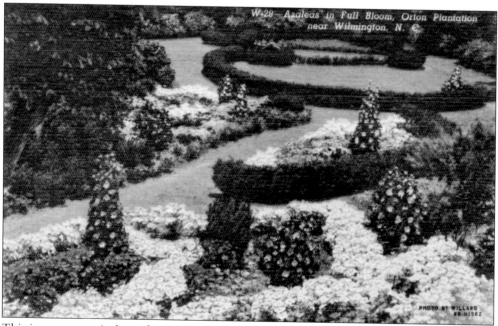

This is a scene to rival any formal English garden design. The goal of the gardening staff was to keep care to a minimum while producing maximum results. This setting would be ideal for a grand garden party.

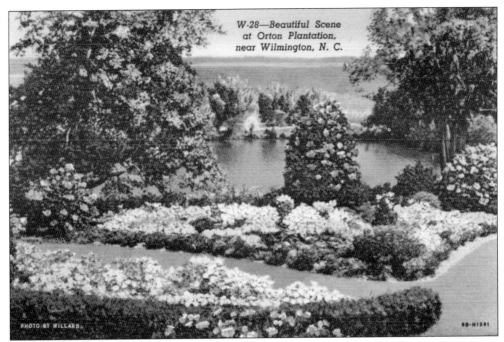

W-28—Beautiful Scene
at Orton Plantation,
near Wilmington, N. C.

PHOTO BY WILLARD

9B-H1561

This is a view fit for a king. "King" Roger Moore could look out his front door to this vista. It was a rice field in his day, before it became a formal garden. The current owner has expressed interest in preserving the land back to its natural state, so it may become a rice field again.

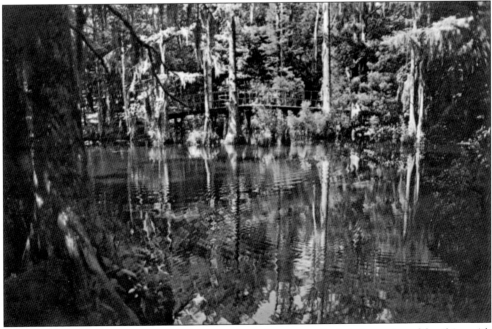

Native North Carolinians harvested turpentine, pine tar, and pitch in settings like this, with mixed forests and ponds. Orton owner Benjamin Smith owned an Eli Whitney cotton gin, but few rented it because cotton was not a big crop in the area.

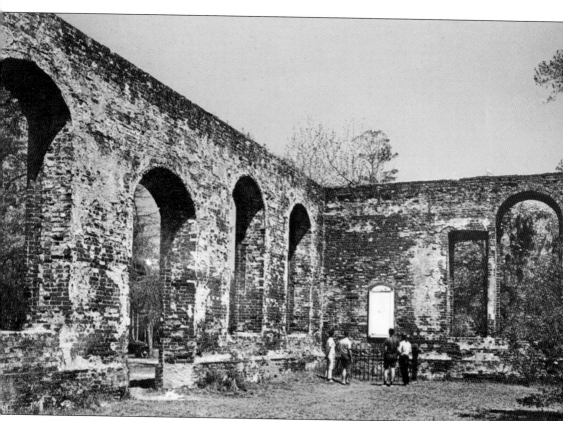

The walls of the former St. Philip's Anglican Church are seen here in the 1950s. They still look the same today. After being burned by the British, shelled by Union gunboats, and used to store bodies of dead Confederates during battle, these walls now stand as a silent reminder of the past. Benjamin Smith wanted to be buried next to his wife here, but he was instead interred at the Old Smithville Burying Ground. His precise burial site is unknown. Mixed with the ashes of the town are those of St. Philip's. The plaque in the center is a dedication.

*Three*

# OAK ISLAND AND FORT CASWELL

## PRAISE THE LORD BUT PASS THE AMMUNITION

Fort Caswell was built in the 1820s to protect and defend the Cape Fear River. Defensive strategies changed after World War II, and it was sold in 1949. It was sold to the North Carolina Baptist Assembly on September 17, 1949, for $86,000, opening a different chapter in the life of Fort Caswell. In 1982, the Baptists faced a decision. With the fort valued at $4.5 million, they decided not to sell, and they renovated instead. They updated, painted, and expanded their assembly grounds. Today, it is a beautiful place with a proud history of providing defense and direction.

The fort is on one end of the 12.6-mile-long by 1-mile-wide Long Beach Island. Both ends contain an inlet from the Atlantic Ocean, dividing it at each end from the land. The Cape Fear River gives access to Wilmington seaport on the east, and Lockwood's Folly Inlet divides it from Holden Beach on the west. Development of the island spawned three towns: Caswell Beach, Yaupon Beach, and Long Beach. The discovery of stone tools nearby suggests it was inhabited for thousands of years by Native Americans. Eventually, in 1999, time and pragmatism made the communities one: Oak Island. In summer, the island's population swells to 30,000 and higher.

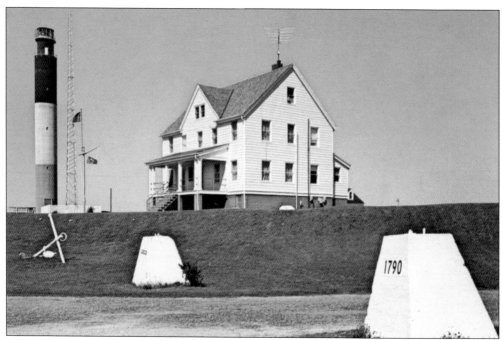

Caswell Light, or Oak Island Light, was built on land that was once a part of the fort. It was also the site of the Oak Island Life Saving Station, seen next to the lighthouse, which was built around 1888. The station was the only hope for many a distressed sailor.

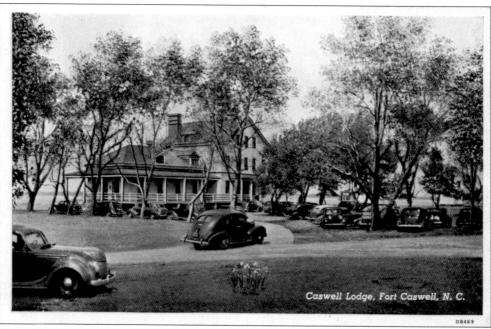

Caswell Lodge was first a hospital in World War I, then bachelor officers' quarters during World War II, and, finally, a hotel with 12 rooms and 12 baths from the late 1940s to the early 1950s. This postcard shows the hotel after it had been "attacked" by gallons of bright white paint. Before that, it had been painted Navy gray or Army olive.

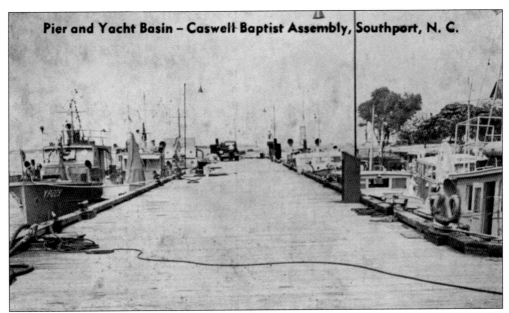

Pier and Yacht Basin – Caswell Baptist Assembly, Southport, N. C.

The old "T" pier was badly damaged by Hurricane Hazel in 1954. A new one was eventually built in its place, as well as a modern, 1960s-style family hotel with 20 rooms. The peak of its roof is seen here on the far right. The new pier completed the new yacht basin.

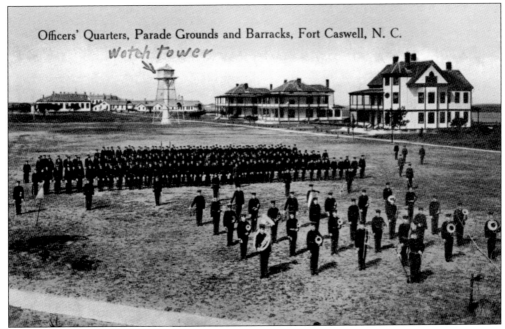

Officers' Quarters, Parade Grounds and Barracks, Fort Caswell, N. C.

Watch Tower

This postcard dates to the first decade of the 1900s and shows painstaking efforts to make this a perfect city with homes designed by rank. The two identical homes are designed for captains. Each house had gutters for rainwater collection and a cement cistern to store it. People had enough water to wash clothes, but they still took saltwater baths with a bit of cistern water to rinse. The band played on and on.

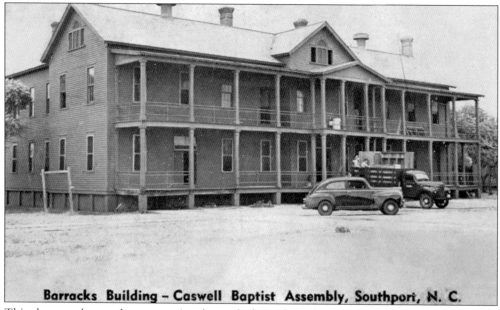

**Barracks Building – Caswell Baptist Assembly, Southport, N. C.**

This photograph was taken on moving day, as the barracks building was being converted to civilian use in the early 1950s. Notice by the military color scheme that it had not yet been repainted. These structures were very well constructed, and many of them remain in use to this day.

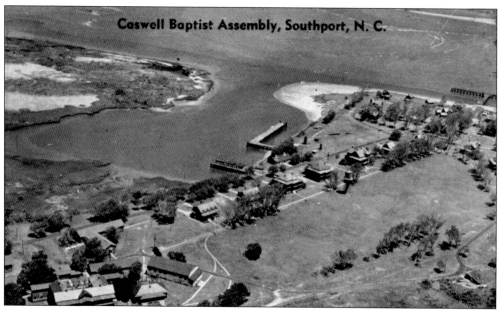

**Caswell Baptist Assembly, Southport, N. C.**

This is an aerial view of the yacht basin and the new pier. The hotel is in the foreground, blended with existing military buildings. In the 1950s, an "invasion" of another type occurred when an "army" of young people "attacked" with paintbrushes. They spread hundreds of gallons of paint over the 70 buildings, transforming them from military colors to stunning white.

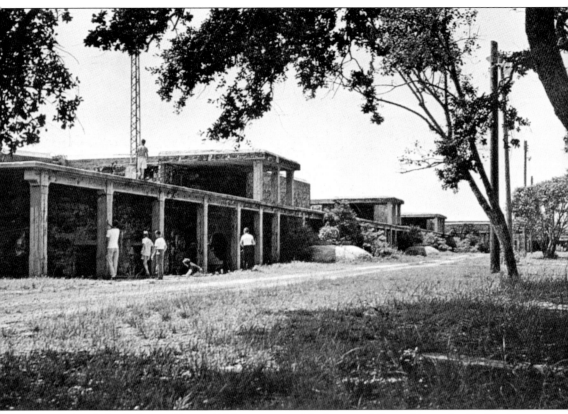

Battery Swift, built from 1896 to 1898, was named in honor of Capt. Alexander Swift, the engineer who built the original fort. This modern work was built of cement and housed four disappearing eight-inch guns. Later, another five-inch gun was added, to utilize extra space and to add a bit of firepower.

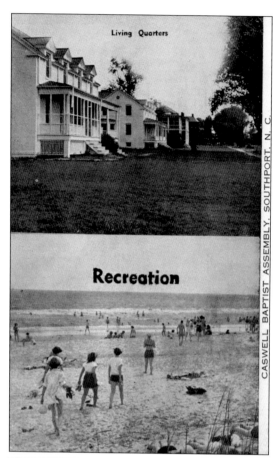

Living Quarters

Recreation

CASWELL BAPTIST ASSEMBLY, SOUTHPORT, N. C.

Reveille started joy-filled days of fun and learning at the Caswell Baptist Assembly. First there was work and then there was recreation at the beach. Dr. Richard K. Redwine, known as "the Great White Father," had snow-white hair and was the beloved leader for many years.

The Drift Inn (below) was a Caswell meeting place offering cold soft drinks, snacks, and hearty discussion. Even the roof was a great spot for "higher conversations." The snack bar was located inside Battery Madison and operated from 1960 to 1985.

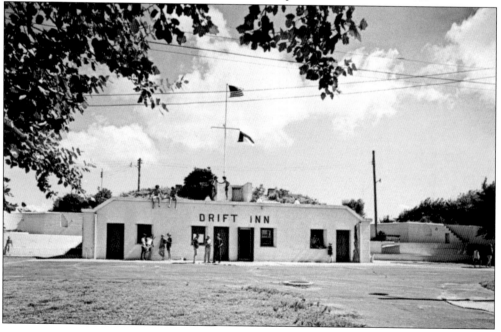

DRIFT INN

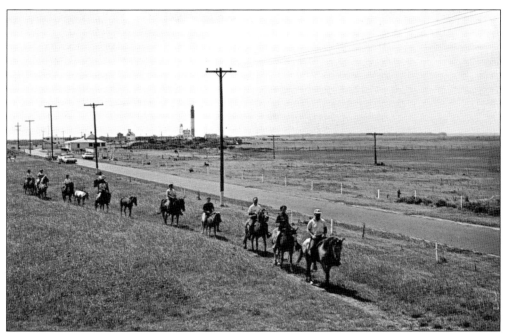

Horse riding has come back to Caswell Assembly. In 1992, a Horse-A-Thon was launched by the Long Beach Fire Department as a fundraising activity. The 20-mile beach ride became so popular that it was supported by up to 400 riders from seven Southeastern states. This event raised thousands of dollars for the department.

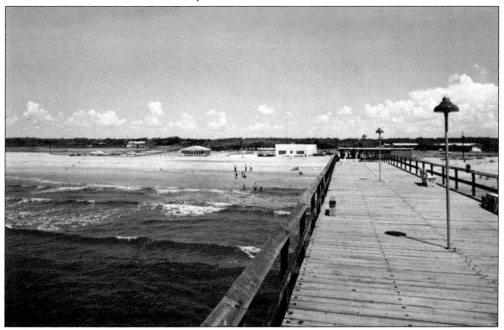

Fishing piers attract both fishermen and those wanting spectacular ocean views. Porpoises often come playfully close to shore, attracted by the pier. Now called Yaupon Pier, this one is temporarily closed, although efforts are underway to reopen it. It was damaged by storms in 1967 but rebuilt by the owners at that time.

The pier is no longer T-shaped, and it continues to expand. More arcade space has been added, as well as an expanded tackle shop. The grill has seating for 55 customers. Storms took away the end of the pier. Heavy tourism translates to prosperity for Oak Island.

Hatch Auditorium was built to feed a need. The Baptist Assembly received this gift from Rachel Hatch, an Episcopalian, who believed, "Baptists have their hand on the pulse of humanity and seek to touch the needs of the people." The doors opened to the sound of trumpets and singing on July 17, 1968. It has been serving Baptists ever since.

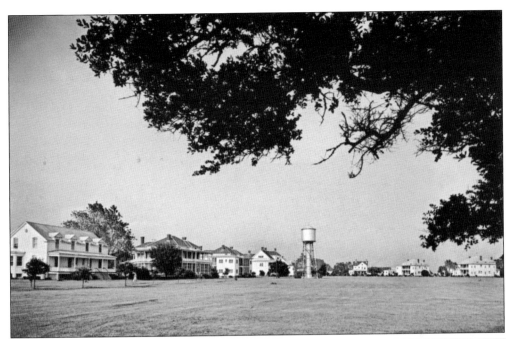

The parade grounds have changed little. A "perfect little city" was built around them. There was a school, storehouses, a mess hall, some barracks, and a guardhouse. Facilities for a blacksmith, a carpenter, and a plumber were also erected. A laundry called Soap Suds Row was one block away.

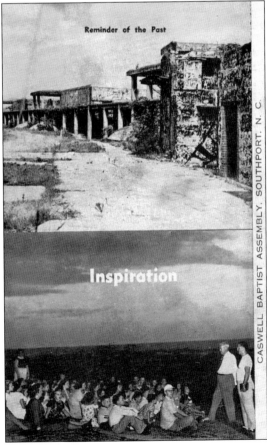

Reminder of the Past

Inspiration

CASWELL BAPTIST ASSEMBLY, SOUTHPORT, N. C.

This postcard shows quite a juxtaposition, featuring both falling down and building up. Below, the beloved Dr. Redwine is perhaps offering inspirational thoughts drawn from the objects of war found everywhere on the grounds. There were hundreds of old cannonballs in 1950. Within 10 years, most of them were gone. The other reminder of war, Battery Bailey (above), seems to be crumbling away.

73

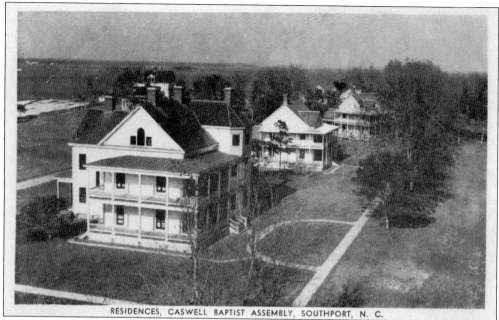

RESIDENCES, CASWELL BAPTIST ASSEMBLY, SOUTHPORT, N. C.

Eddie Jelks was the sole caretaker of the fort until 1932. He lived in an elegant home like these. A mascot of the Wilmington Light Infantry named Woodrow Wilson became the progenitor of the goatherd used to keep the grass short. Today, it takes about 30 full-time employees to keep the Baptist Assembly going year-round. Many participants return repeatedly to experience spiritual reawakenings.

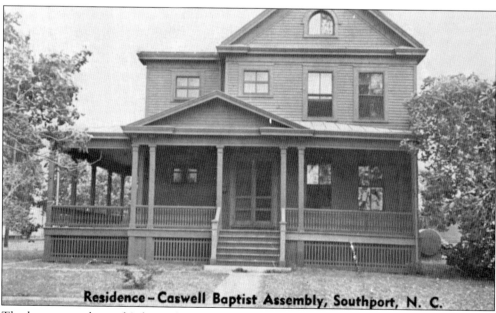

Residence – Caswell Baptist Assembly, Southport, N. C.

The large veranda on this home invites roller-skating. Shortly before this time, two artesian wells were reactivated near this home to provide heated water for the swimming pools. The mineral water ruined swimsuits.

The Lantana Church Group Cottage is seen here in the 1950s. It was easy to take one's mind off a busy world in an ocean-side setting like this. By June 1950, the Baptist Assembly was open for business. In that first year, 4,331 Baptists attended.

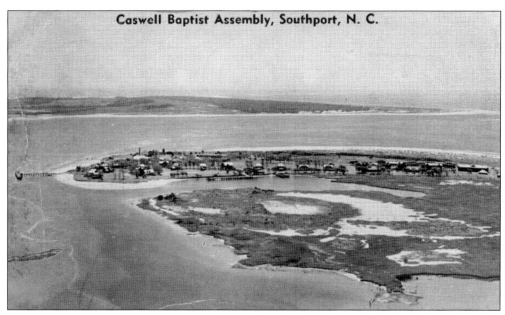

Caswell Baptist Assembly, Southport, N. C.

This image shows how Fort Caswell was a very defensible position. It is a pinch point for both friend and foe. Fort Caswell figured correctly that submarines might sneak into the area, and they had a gift for them: a string of submarine mines and a switchboard to detonate them, making for unhappy days for the submariners. The submarine boat dock is on the left.

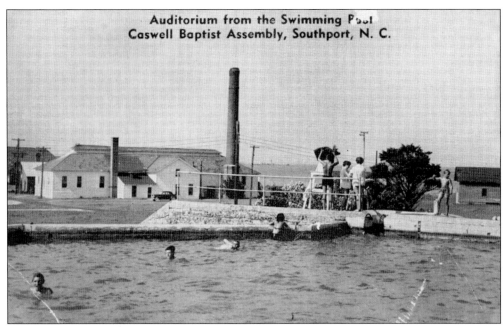

Auditorium from the Swimming Pool
Caswell Baptist Assembly, Southport, N. C.

This old gun emplacement was bulletproof, watertight, and made of concrete, making for a great swimming pool. The Baptist Assembly had two of them. Behind it is the old auditorium and gymnasium, built in a former power plant. Prominent artists performed for the men during times of military engagement as a way of donating to the war effort. The Baptists used it until 1968.

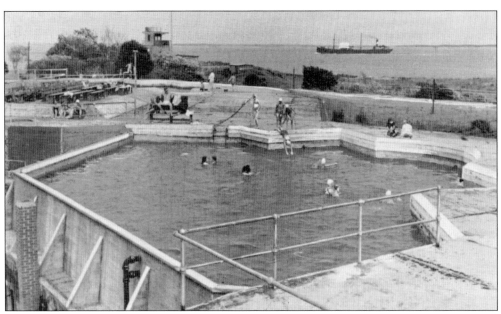

The second pool is seen here. With such high structures, it was never necessary to turn off the lights during World War II blackouts, as the batteries blocked all illumination and no light could be seen. There were no diving boards, as neither pool had a deep end.

In 1903, Cape Fear Light, a 150-foot structure, was built on the tip of the island to aid navigation near the dangerous Frying Pan Shoals. Old Baldy was too short.

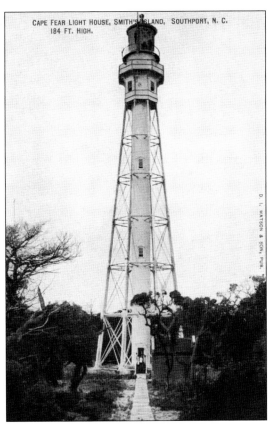

Old Prices Creek Lighthouse was one of eight "range" lights leading shipping to Wilmington. It was a rear elevated light and no longer exists. It worked in tandem with a lower, front range light that still stands today. A ship could line them up to stay on course. This light never recovered from the Civil War. The building collapsed, but the bricks can still be found today. Although the light was never relit, it still shines on as a symbol of survivorship. It is used today as a symbol of strength for the Arthur Daniels Midland Corporation, its new owner. The "corn-crackers" fleet brought corn to Wilmington past this light. Two of these small sailboats with bright sails were called *We're Here* and *So are We*.

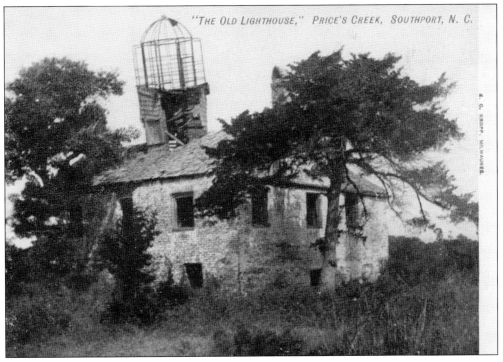

These walls were three feet thick but rose only 20 feet off the ground. The Prices Creek front range lighthouse offered this intrepid visitor a unique perch. It is now on private land and receives minimum maintenance from the owner. The sixth-order Fresnel lens would have provided a steady white light from the framework on top. The Caswell light leads to this station, which was then the only means of communications between Caswell and Fort Fisher at New Inlet. The beach in front of the light remains much the same today as it was when the light was built in 1848. It is the sole survivor of the series of eight lights built between 1848 and 1851.

The Oak Island Lifesaving Station operated on the North Carolina coast from 1874 to 1915. It then became a part of the Coast Guard. Their duties are to search for, rescue, and assist disabled craft at sea. Years ago, the beach was patrolled on foot and horseback. The duty man walked to a "key" post and then turned the key and walked back. The rescue boat was launched from the shore. Many did not come back.

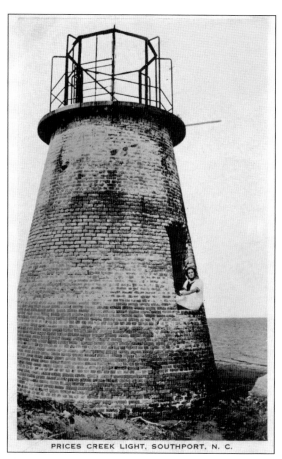

PRICES CREEK LIGHT, SOUTHPORT, N. C.

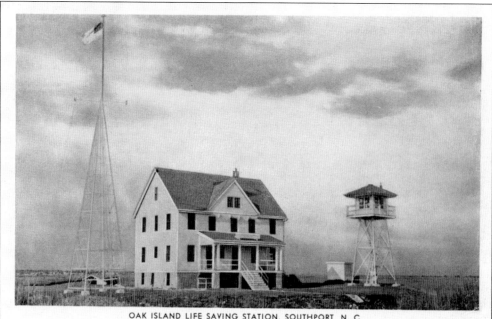

OAK ISLAND LIFE SAVING STATION, SOUTHPORT, N. C.

Caswell Beach, Yaupon Beach, and Long Beach decided to join together in the 1980s, becoming Oak Island. The area needed fire protection, and matching money to help build two fire stations was provided by an ongoing fundraiser, a 20-mile horse ride on the beach known as the Horse-A-Thon. It raised thousands of dollars, and the event became popular with horse lovers across a large cross section of the Southeast. The event was held in March for over five years, and the result—the two fire stations—will continue to serve islanders for years.

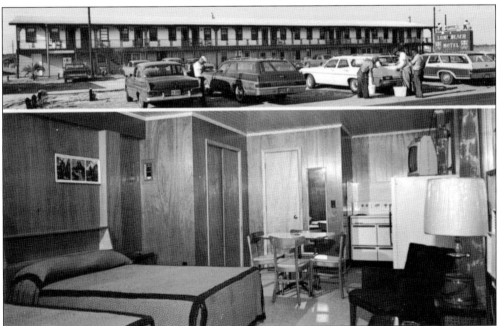

The addition of the Long Beach Motel made Long Beach a destination location. The adjoining pavilion had everything the angler or vacationer could want. The early 1960s brought many changes to Long Beach. A bakery opened nearby, and Southern Bell Telephone & Telegraph completed the new automatic exchange building to service Long Beach.

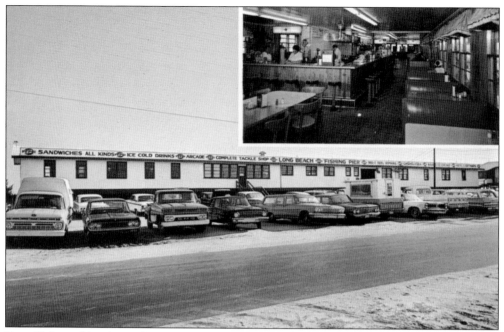

Even if the parking lot at the Long Beach Pier is crowded, the owner will make room for new arrivals. Carl Watkins has always been a community-minded business owner and was a pioneer year-round resident. He was instrumental in starting the Long Beach Fire Department, and he and his family were also supporters of Dosher Hospital in Southport.

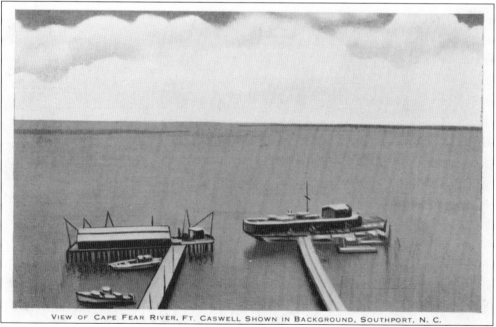

VIEW OF CAPE FEAR RIVER, FT. CASWELL SHOWN IN BACKGROUND, SOUTHPORT, N. C.

This postcard shows a time when the channel was not deep enough to permit big ships bound for Wilmington through. Thus, cargo would be "lightered" onto small ships for the final journey. Once "New Inlet," which extended just outside this image to the left, was closed, the problem was solved. This difficult engineering feat took six years to accomplish.

The Oak Island Golf Club has an abundance of water holes. Surprisingly, archeological finds keep turning up in the area. Arrowheads and pottery shards are common. Once, not far away, on Thirtieth Street East, a resident pumped seawater into his house. There, through a maze of valves and filters, he attempted to extract gold from that water.

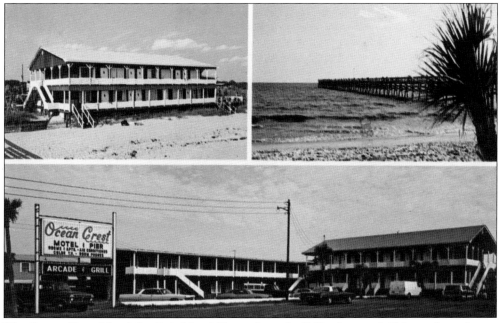

The Ocean Crest Motel fits Oak Island like a glove. In 1962, close to 1,000 people took part in the state crab derby, when 16 million pounds of blue crab were taken from state waters. On February 22 of that same year, the Washington's Birthday Fox Round-up bagged 33 foxes.

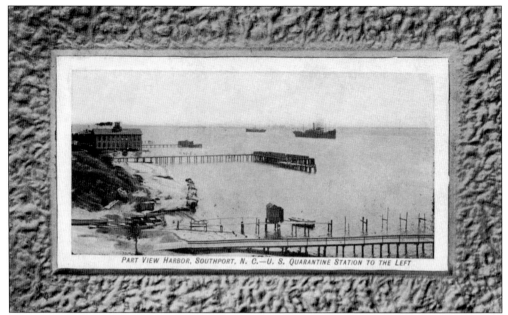

PART VIEW HARBOR, SOUTHPORT, N. C.—U. S. QUARANTINE STATION TO THE LEFT

Even the quarantine station pictured on the far left could not stop the yellow fever and smallpox. Boatloads of Wilmingtonians relocated in Smithville to escape the fever. Every house was full. For many, it was too late and they died looking at this beautiful view called Smthville Harbor. Only a few Smithville citizens contracted this dreaded disease.

The Oak Island Lighthouse is seen here on Caswell Beach, with the Oak Island Lifesaving Station to the right. It is now in private ownership and receives loving care. Looking out into the Atlantic, one often sees a large number of birds, hovering over the discharge from the nuclear power plant more than five miles away. The birds are drawn there because the mildly warmer water attracts fish.

_Greetings from_ **Long Beach N.C.**

This postcard shows another Carolina blue sky at the beach. Some of these beaches are rated highly by those who know their beaches. Sea Oats, a grass that resembles grain, protects the beaches. Even after Hurricane Hazel in 1954, it began a return. It will grow where almost nothing else will and provides a means of limiting erosion. Understandably, it is illegal to damage it in any way; gathering rays from the sun, however, is perfectly legal.

It is great fun to rent a shallow-draft craft to explore the marshes or Long Bay. Renting one made for just this will take visitors to the best spots to fish. The Blue Wave Marina also has half- and full-day fishing excursions.

Greetings from Long Beach, Southport, North Carolina

These gentle, rolling waves have deposited tons of shells on the beach. Early residents found them in such abundance that the shells and whelks were hauled by the truckload to make paving for roads, walks, and driveways. Soon, the removal of shells for commercial purposes was banned, but personal collection is still allowed.

A young sailor poses for the camera in front of Oak Island Lighthouse. On a clear day, from the top of the lighthouse, one can see to Lockwood's Folly Inlet and beyond, including the Frying Pan Shoals, the Cape Fear River, Bald Head Island, and all of Southport. The various lagoons, creeks, and marshes that are seen produce much local seafood. The Oak Island Lighthouse is one of the first things seen when departing Southport by ferry. This 189-foot beacon was constructed in 1958. The top section was installed with the aid of a Marine Corps helicopter.

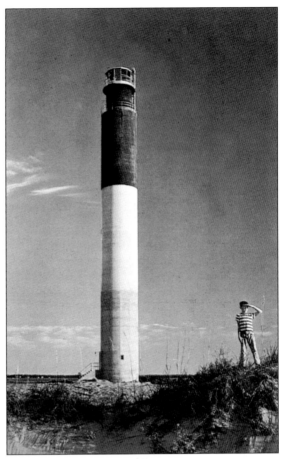

The moonscape below shows Bald Head Lighthouse, or "Old Baldy," looking toward Long Beach. It is a very peaceful place. The climate on Oak Island seems right for writers, and many yarns have been spun there. Herbert Bell tackled the writing of his book, *How to Get Your Book Published*, while staying there.

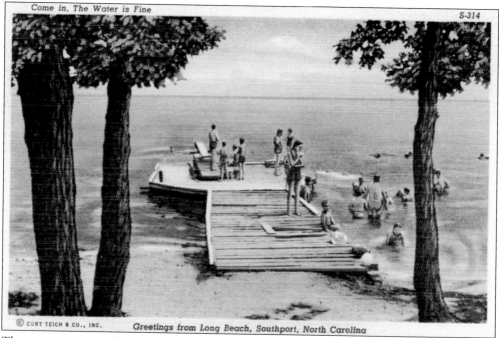

© CURT TEICH & CO., INC.    *Greetings from Long Beach, Southport, North Carolina*

There were some small family docks on Oak Island, but they were always vulnerable to wind and storms if they were on the ocean side. These sandy shores are the nesting grounds for loggerhead turtles. The full moon in June causes them to come ashore and lay their eggs in the soft sand. Sun and nature then take over.

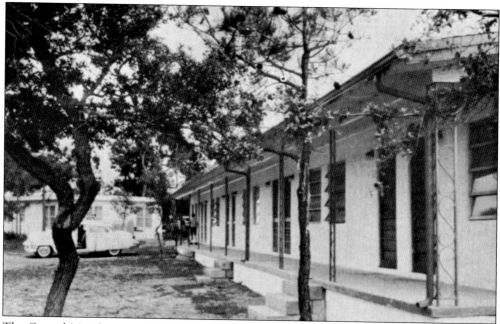

The Coastal Motel, seen here, was opposite the Long Beach pier. Rooms at the Coastal came with and without kitchenettes. The 1951 or 1952 Cadillac in the background was a new design. Its gas cap was not visible, as it was located under the swing-away rear taillight.

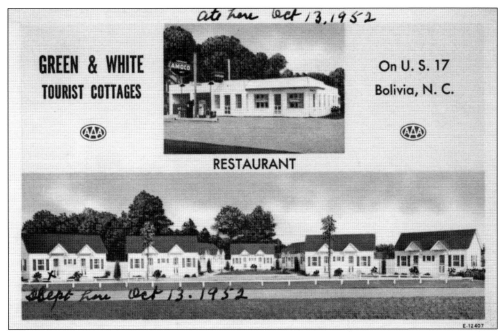

America was changing in the 1950s. After the Eisenhower administration built a national highway system, these tourist cottages became very popular. One had a good place to sleep and then they could gas, grub, and go. Visitors to Long Beach had to schedule their trip to go over the drawbridge when it was open. A high-level bridge was not built until 1971.

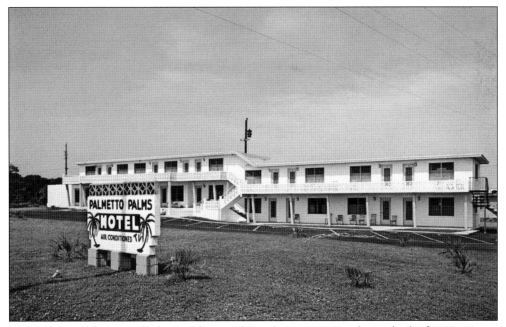

The Palmetto Palms Motel, along with everything else on Long Beach, was built after Hurricane Hazel leveled the island in 1954. In one story of the hurricane, a couple on their honeymoon rode out the storm clinging to a mattress. They had spotted a foam mattress floating by and clung to it. They were able to dodge houses coming at them as fast as 50 miles per hour.

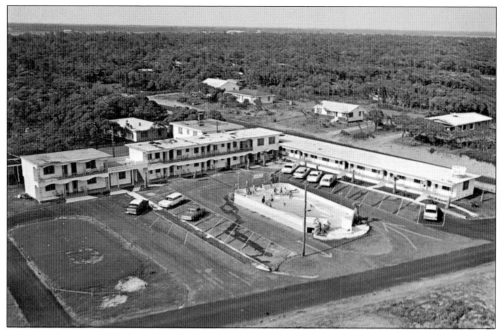

This modern motel, presented in an aerial view, was part of a massive Oak Island rebuilding in the 1960s through the 1970s. Hurricane Hazels' visit allowed for improved design and strength. Oak Island became a destination location with a basket full of choice things to do. Predictably fine beach weather, Gulf Stream fishing, and multiple historical sites close at hand made this a preferred destination. Some chose to stay at this idylic spot.

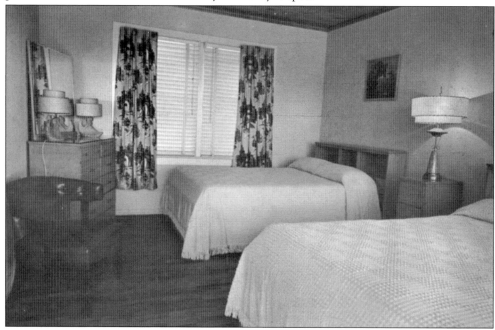

This is what the inside of a modern motel on Oak Island once looked like. The windows show that air conditioning had not arrived yet. Many motels expanded by adding second floors, which, in turn, expanded profits.

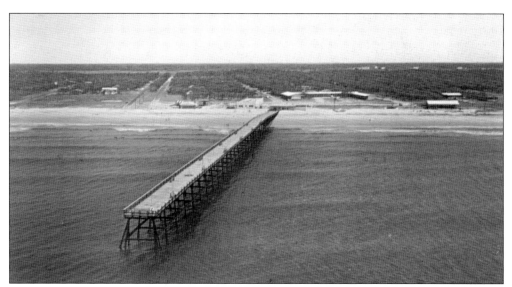

There is growing concern that natural replenishment will not be enough to continue the prime attraction of a pristine beach without some human intervention. The shifting sands of the beach itself give concern to many. Proud homeowners can select a prime spot to build their dream cottage on the beach, only to find themselves with an unwelcome visitor: the ocean. Sand builds up on this beach, as it does on many beaches. However, it is more common to see sand disappearing as storms scour the beaches. Beach nourishment is a prime concern of beachgoers, as well as those who own beachfront homes. Luckily, not even Hurricane Hazel took away sea oats, the hardy plant that seems to grow where almost nothing else will. If a dune begins building behind a favorite beach, it is a very good thing.

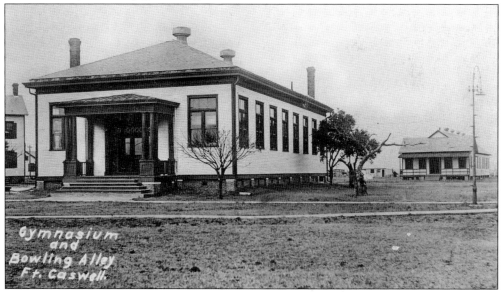

This building was the forerunner of the YMCA. Southport had previously built an Army-Navy Club as a community gathering place. Caswell constructed this building to help grow what Southport had already put in place. Through the years, it was not uncommon to find shells or cannonballs lying around Fort Caswell. When the North Carolina Baptist Assembly took over, the ordnance scattered everywhere was a grave safety concern.

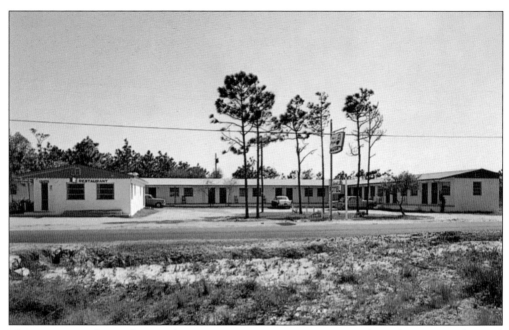

This was a new design for motels across America. It was a step away from the tourist cabin and a move toward more efficient design. If the "Eisenhower-driven" highway system sent more guests to the door, you just added a second floor. This unit is located on the old Post Road just before the turn leading to the beautiful vacation spot of Long Beach.

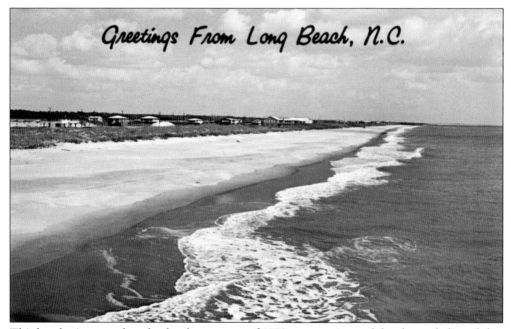

This beach view may be why, by the summer of 1972, economists and developers believed that Long Beach was more than just a vision. The beach is clean and the water is warm, and the food and lodging are very good. A spot on a fishing pier can be easily had, and visitors will not find better Southern hospitality.

*Four*

# BALD HEAD ISLAND

## THE UNIQUE, THE SELECT, AND THE FEW

The infamous Cape of Fear was a scourge for countless mariners who have shipwrecked on Bald Head Island. It is not all bald, however, as there are plenty of second-growth cedar, palmetto, and, particularly, dogwood trees. It guards the mouth of the Cape Fear River and North Carolina's only major seaport, Wilmington. Our nation sees it as a strategic location during wartime. The bald head itself is the first part of Smith Island seen by both friend and foe. A boundary between the temperate and semitropical zones exists there, making it an ecologist's dream. This also seems to attract those seeking respite and retirement, as the wealthy, the select, and the few have been drawn to it.

In 1713, Landgrave Thomas Smith Sr. issued a land grant to his son Thomas Jr. for what is now called Smith Island. It was a politically and militarily driven decision. A lighthouse was needed to help avoid those dreaded Frying Pan Shoals, and the subsequent owner of the island, Benjamin Smith, gave land for "Old Baldy" to be built. The construction cost in 1794 was $11,359.14. That first structure crumbled within 20 years. The second "Baldy" was built in 1817 and still stands today. However, it was immediately discovered to be too short and dim to be useful. It was eventually decommissioned in 1959. While Oak Island Lighthouse replaced Baldy, it still remains the oldest lighthouse in North Carolina.

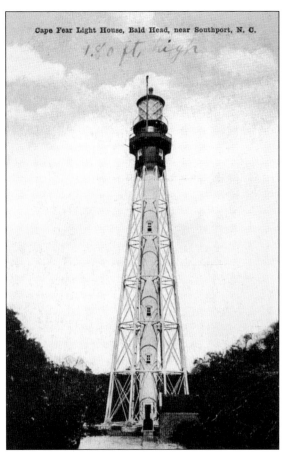

Cape Fear Light House, Bald Head, near Southport, N. C.

1.80 ft. high

Construction on Cape Fear light was a year and a half behind schedule, as Congress could not complete the appropriation aspect of the project. It was going to cost upwards of $70,000. Almost from the start, this light did double duty. It replaced the flagpole at the lifesaving station as the signal tower for the flags used to inform the Oak Island lifesaving crew, the Southport Pilots, and the tugboat companies of vessels in distress. It was easy to be the first person to spot a distressed vessel by climbing the tower. This light was bigger and better, but many worried that Old Baldy would be shut off. Instead, it was changed to a fixed light and renamed the Bald Head Light Station. It burned steadily until 1935, when it was changed to a first-order flashing lens. It blinked every 30 seconds until 1958. Baldy is still a day marker for craft on the Cape Fear.

The island's mix of palmetto, oak, cedar, and dogwood trees makes it biodiverse in a way that many islands in the Southeast are not.

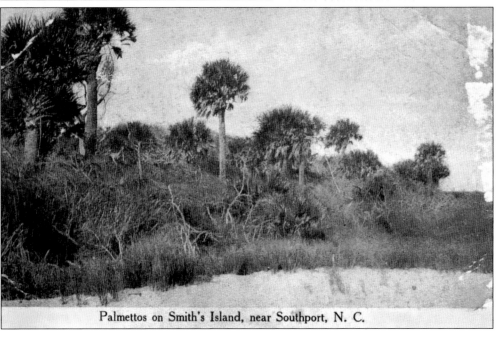

Palmettos on Smith's Island, near Southport, N. C.

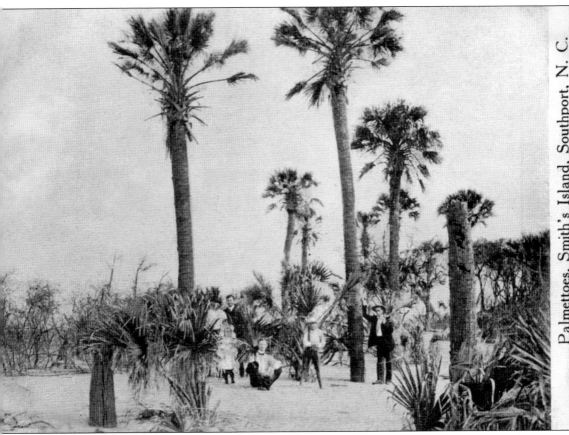

Perhaps this 1890s postcard was a catalyst for the first developer of what became Bald Head Island. Thomas Frank Boyd bought the island in 1916 and built everything around "the beautiful Palmetto's of the tropics." He developed a grandiose plan and claimed to have sold at least 40 lots by 1945.

On Bald Head Island, Wilmington, North Carolina

Perhaps this is a last attempt to sell the sizzle of "Palmetto" Island: a lovely lady standing by a Palmetto tree. Thomas Frank Boyd built a pavilion that was later destroyed, as well as an unfinished and unoccupied hotel. He sold nearly one million board feet of cedar trees overseas to be made into pencils. Eventually, he tried to give the island away, but even the federal government turned down the offer. A brick press from the building of the hotel remains, but very little else is left of the Thomas Frank Boyd era.

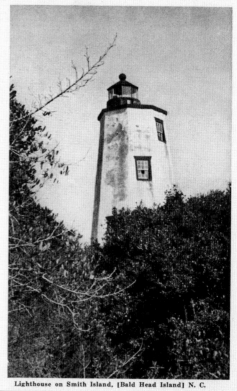

Lighthouse on Smith Island, [Bald Head Island] N. C.

Boyd had several postcards made as part of his Palmetto Island promotional campaign. This one shows a lighthouse with a solid foundation of "hard brick." It is octagonal in shape and exactly 36 feet at the base. The bricks used for paving the ground floor are still in place today.

94

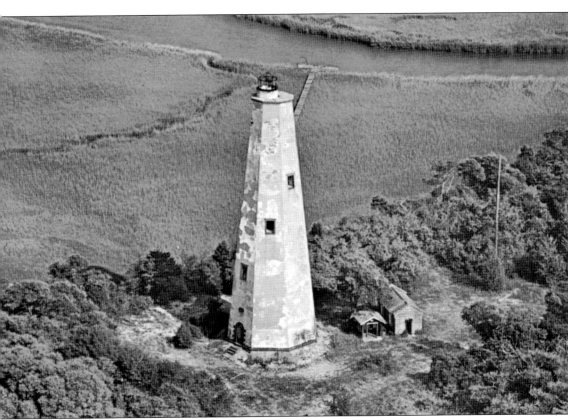

This view of the lighthouse shows the windows, door, and base of the light platform. The strong, 10-inch-by-12-inch panes of glass for the double-hung windows were made in Boston. The marble slabs supporting the "lantern" floor protrude 15 inches for added strength. The doorway is three feet wide and five feet, five inches tall. It hangs on iron hinges with an iron lock. Second Baldy, as it is known, is well built. To the right is the caretaker's house, probably lived in by Sonny Dosher.

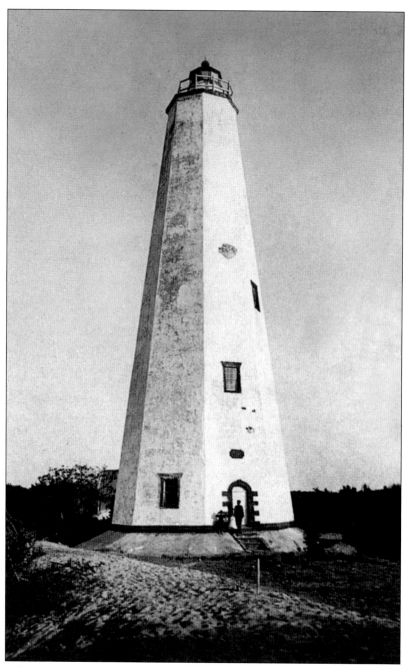

It was clear from the start that Baldy was too short to be very useful. It was eventually upstaged by a 184-foot-tall steel tower with an 18-mile range. The Cape Fear Lighthouse served until 1958, when it, too, was upstaged by the present Oak Island Lighthouse. The Cape Fear Light became known as Captain Charlie's Lighthouse, after Charles Swan, the keeper for over 30 years. In Swan's case, the term captain is one of custom and respectful admiration, not official rank. He and his wife raised nine children on the island, and all were taught to respect the bounties nature provided them there. Bald Head was paradise for a child. There were miles of beaches for a sandbox, the ocean for a swimming pool, and acres of forest for a zoo.

This 1957 Packard is parked in front of the Green & White Motor Court. Centuries before motor courts were built in the area, this location on Route 17 (formerly the National Road or Post Road), was unquestionably passed by George Washington on his southern tour.

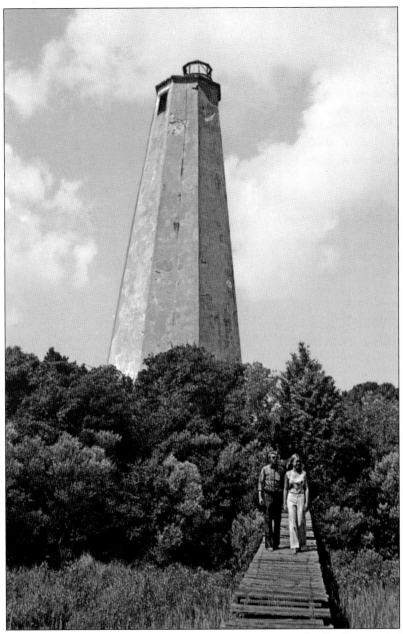

Construction of the Cape Fear Lighthouse began in 1903. It was finally decommissioned and demolished in 1958, but it refused to fall. The original design made certain that the thin tower was adequately braced. Demolition experts were brought in to put it safely on the ground. Large holes were cut in the supporting columns and dynamite charges were set off. The Coast Guard man in charge at the time watched in amazement as the charges had no visible effect on the structure. More of the supports had to be carefully cut away from the wrecked structure. The second attempt was successful, toppling the tower and leaving only a pile of debris where the Cape Fear Light had stood. Charles Swan, or "Captain Charlie," the former lighthouse keeper, would have been sad to see it go but happy that it served such a long and protective life. Old Baldy watched the whole process and, had it been possible, probably would have smiled broadly.

Bald Head is a safe haven for unique, location-oriented plants and people. The biological diversity of the plants on the island is not found anywhere else. It is unusual, for example, that there are so many dogwood trees on the island. There are theories about the dogwoods and other unusual plant life, but there is no definitive evidence as to why the island is the way it is. One thing is certain, however: it is a great place for a child to grow up exploring.

E-1006

This would be a perfect stop at a guest cabin before the short ride to the Bald Head ferry terminal. There were no nearer accommodations in the 1950s, and no drawbridge to cross. Bald Head can never again be as wild and unmolested as it was when the children of Charles Swan ("Captain Charlie") used it as their playground, but it can preserve a history of mystery and intrigue. Careful conservation activities by knowledgeable residents should help preserve a peaceful coexistence with nature. The sentimental attachments to this landmark are strong as well as meaningful. Bald Head will continue to grow, but it is being developed in accordance with a reasonable plan to make a minimum impact on the environment. Many of the residents say that this is the way it should be done.

## Five

# BRINGING IT
# ALL TOGETHER

## TREES, TURTLES, AND TORPEDOES

Southport has been home to many interesting people, who have made the community what it is. They include Robert Ruark, a native son and the author of *The Old Man and the Boy*; J.R. Dosher, one of the last country doctors, whose operating room was your kitchen table; and G.W. "Mack" McGlamery, the owner of Mack's Café, who welcomed guests if they also welcomed his dog. Either a visitor let the dog sit with them or they were the ones asked to leave. Potlicker, the town dog, was prone to snoozing beneath the solitary traffic light. Bill Keziah, the deaf and nearly mute local newspaperman, wrote that Potlicker was also the only dog known to have a charge account. Keziah was known as the town's "one-man chamber of commerce." Not every town has a pirate, but Southport had Stede Bonnet.

Capt. Eugene Gore also had much to share with the town. He lived to see the fruition of Martin Luther King Jr.'s dream. In his recent obituary, after he passed away at age 96, two full columns were needed to chronicle his life. On March 12, 1942, the *John D. Gill* was struck by a torpedo delivered by German U-boat No. 158. Southport was there to care for the survivors and mourn the lost. Oak Island also showed a strong spirit to rebuild after Hurricane Hazel destroyed the island town in 1954. Looking forward, Bald Head Island citizens are bringing concentrated conservation efforts to their most unique home, Orton continues to grow and change, and Southport has recently begun celebrating the Charles Dickens Festival in the fall.

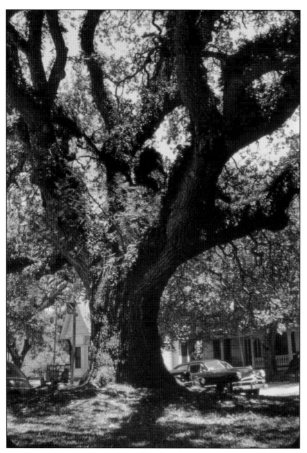

The live oak grows naturally in the sandy soils of the Southern coast. Its branches are very long and often arch to the ground. They stay green all year, shedding old leaves in the spring when new ones grow in. The "live-oaking" industry ended when wooden ships became obsolete. The curved limbs of the live oak had been in demand for the ribs and knees used in shipbuilding.

Looking at all its live oak trees, the tops of which are seen here, gave the city of Southport a good idea. Instead of having a homecoming event, why not have a live oak festival? The all-day event began in 1952, celebrating these hardy trees as part of its Fourth of July festival.

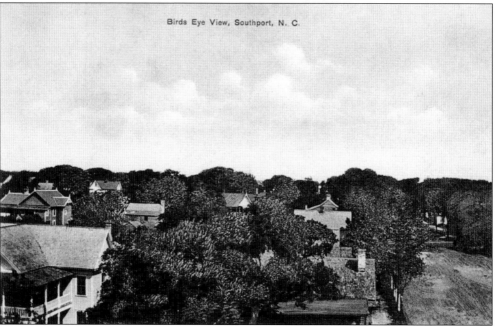

Birds Eye View, Southport, N. C.

The *John D. Gill* looked similar to this ship seen sailing toward Wilmington. It was struck in 1942 by a single torpedo just off Carolina Beach. German U-boat No. 158 was responsible. The boat had a rookie skipper with a remarkable "kill" record. The good citizens of Southport looked all that day and night for survivors and bodies. In the end, there were 15 survivors and many dead. The townspeople reached out to all in hopes of bringing closure to families. U-boat No. 158 went on to destroy 20 ships before being identified by Caswell surveillance equipment and cornered by air and sea attackers. Most of the charges missed and it appeared to slip away, but one lodged in its conning tower and exploded as the submarine reached the preset depth of the charge, killing all aboard. The young German submarine commander was given great honors by his country when his body was returned to Germany.

This postcard shows sailboats at the Southport Oil Company dock. The local shrimp industry started in the 1910s, and the first boat used was a 30-foot sailboat not unlike this one. The market for shrimp as something other than bait needed to be developed, and selling that product at a reasonable price seemed logical. However, even pricing it at $3 per bushel was not getting people to eat it, so the effort took a lot of coaxing and salesmanship. The United States Bureau of Fisheries tried to help, but the local fishermen were more interested in finding and propagating flounder. Spawning grounds for shrimp production just were not commercially viable. Eventually, however, shrimping became a big industry in Southport.

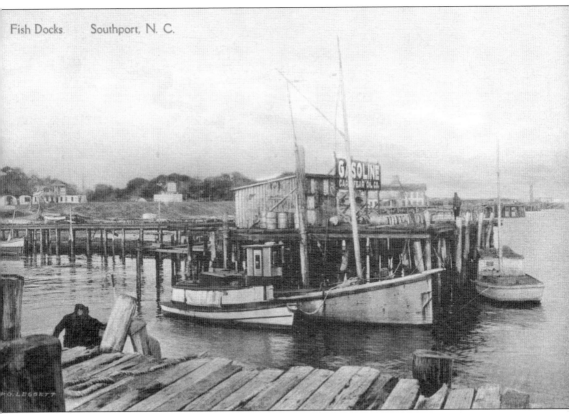

Fish Docks.   Southport, N. C.

Gas power changed fishing and shipping. Having a dependable energy source brought many options. After a market for eating shrimp was created, they were refrigerated and sent by rail to places like the Fulton Fish Market in New York City. Southport had an ice plant now and could ship 30 rail cars a year up and down the East Coast. Prior to 1954 and Hurricane Hazel, 200 to 300 boats daily offloaded 40–60 bushels each during the season. Today, there are plans for a new aquaculture shrimp industry.

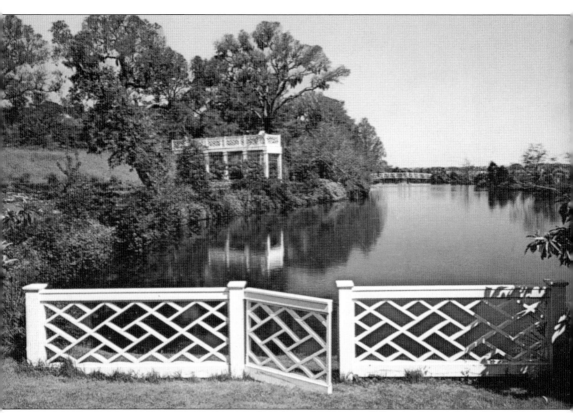

Orton Pond, seen here, was once part of a massive river bastion extending from Fort Anderson during the Civil War. It was up to eight miles long and included impediments by the river to obstruct vessel movement. Until 1907 it was not illegal to leave a gate open. But good gates could protect a town like Southport, and so fines up to $10 were possible if the town gate was left unhooked, unlatched, unfastened, open, or even partially open. Damaging or destroying a public gate was another $10 fine.

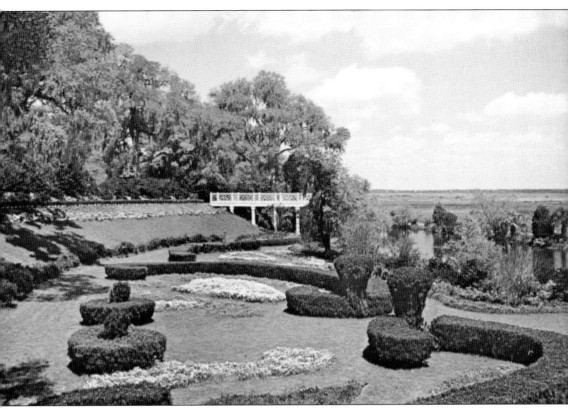

This photograph was taken from the same spot as the image on the opposite page. The carefully planned work of landscape architects and skilled horticulturists transformed a mere pond into a work of pleasing topiary art. The slanted wall by the patio once served as a Civil War earthworks attached to Fort Anderson. Not long after the war, two men explored what they thought was an empty powder magazine near here. When they lit a torch to see, it caused an explosion that blew both of them out the door. Several days later, on March 7, 1866, the coroner's report for one of their deaths read, "Deceased came to his death from burns caused from the explosion of a Confederate magazine at Fort Anderson."

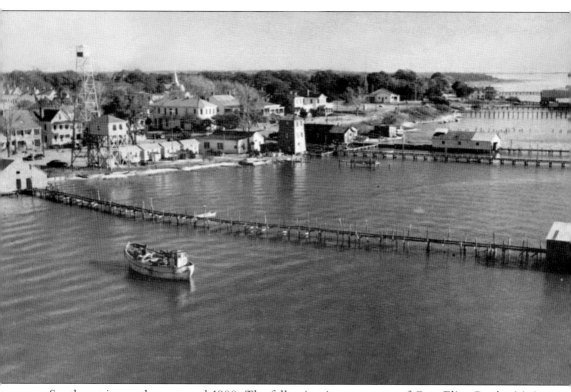

Southport is seen here around 1900. The following is an account of Gov. Elias Carr's visit in 1895 from the Raleigh *News and Observer*: "The Governor planned a winter season visit at which time this place has a particular charm to upcountry visitors. He and his group arrived as guests of Captain John W. Harper on the steamer *Wilmington* and they greatly enjoyed the noble Cape Fear River where features of interest to every North Carolinian were explained by Captain Harper and his brother Captain Tom Harper."

*1991 N.C. WATERFOWL STAMP*

**$5.00**

058906

Expires June 30, 1992

The account continued, "Governor Carr and his guests went duck hunting on Smith Island through the courtesy of Dr. Eager, Captains J.W. Harper and Tommy Harper plus Mr. Stevens. They spent the day wandering through acres of Palmetto Groves and then enjoyed a pot luck dinner with the Cape Fear Life-Saving Crew. That evening Mr. and Mrs. Stevens gave an informal tea for the Governor and his guests. Afterward they went to Dr. Eager's home where the play of *A Proposal under Difficulties* was presented to the amusement of all present."

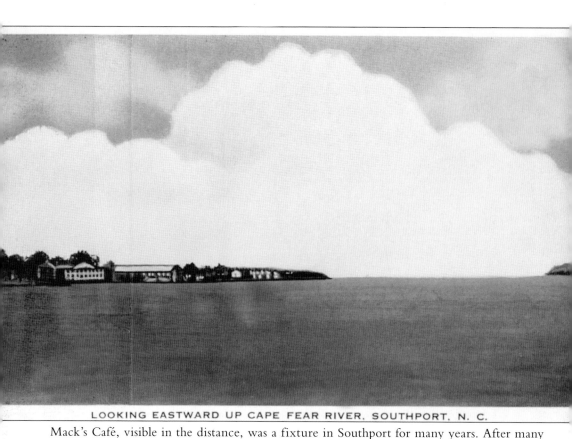

LOOKING EASTWARD UP CAPE FEAR RIVER, SOUTHPORT, N. C.

Mack's Café, visible in the distance, was a fixture in Southport for many years. After many name changes, it is now known as the Ship's Chandler, but it still provides excellent food and an outstanding view of the waterfront. Oyster roasts have often been held there. In 1963, one patron found a black pearl in an oyster during a roast. Hurricane Hazel wiped the waterfront just about clean in 1954, but Mack's survived. The water damage was significant, as it was hit with an eight-foot surge. Shrimp trawlers came over the seawall and rested by the mere shells of buildings. Great oaks along Bay Street were uprooted and finally came to rest on rooftops. The fuel docks and shrimp packinghouses were destroyed and piled high on the shore. The same hurricane also caused the total destruction of Oak Island. The eye of the storm went directly over both towns.

Hurricane Hazel also destroyed Long Beach. Only five of the 357 houses remained. The storm also formed a new inlet on the island. Hazel packed winds in excess of 130 miles per hour, and Long Beach had a 10-foot surge. Making things even worse, it hit at high tide. Thankfully, there was only one loss of life. Some homes were moved intact to locations 500 feet away.

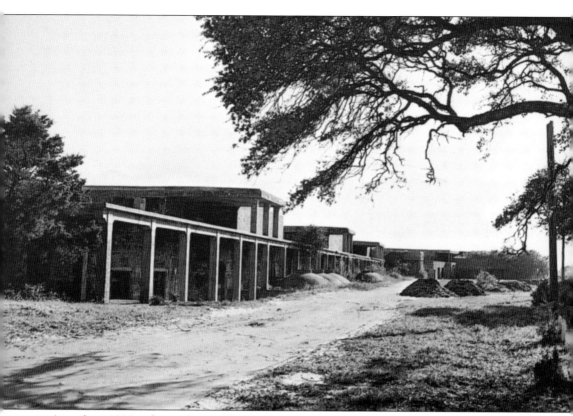

As early as 1825, a fort at the tip of Oak Island was deemed necessary. Swift Battery is where it all began. Excavation is underway here to search for artifacts. Joshua Potts had lobbied Congress for years to build a fort to protect this town of 300 "Smithvillians." Approval came in 1825, and by 1838, Fort Campbell (named for the first North Carolina governor) was almost complete at a cost of $473,402.

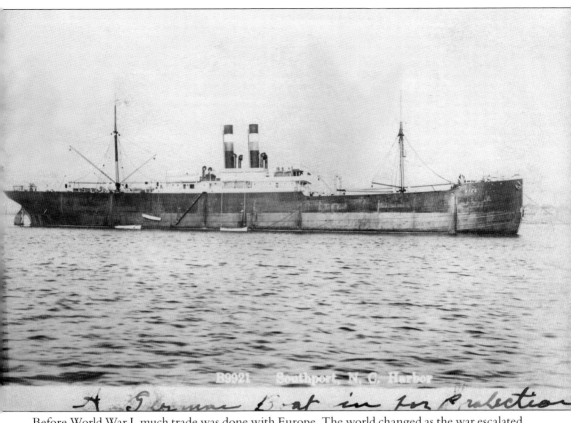

B9921    Southport, N. C. Harbor

*A German Boat in for Protection*

Before World War I, much trade was done with Europe. The world changed as the war escalated, however, and friendly German steamships like the *Kiel*, seen here, were replaced by those hunters of the deep: German U-boats. Because ships had to slow for the Frying Pan Shoals, it made for great hunting for the U-boats. During the war, the Atlantic Oil Company owned a tanker called the *John D. Gill*, which was escorted to Charleston by a warship and then continued on up the coast unprotected. German U-boat No. 158 caught it with one torpedo, and it struggled to make it to safe harbor in Southport. Thousands of gallons gushed from its open bunkers, but none of it caught fire. A big oil slick made it hard, but the good citizens of Southport helped survivors to safety and recovered the bodies of the dead. Catalino Tingzon, a Filipino cabin boy, gave his own life to help 15 members of the crew survive.

Jones Seafood, established in 1965, is noted for its hush puppies and for the friendliness of the Jones family, who are always on-site. They have supported the youth of the Ocean View Methodist Church for many years; a meeting room for church youth has been built out back.

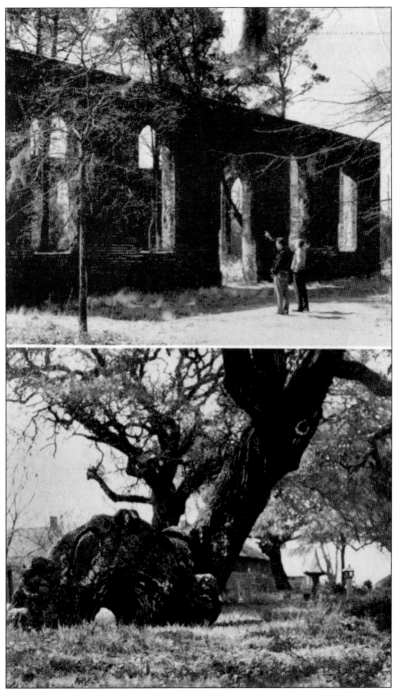

The walls of St. Philip's Anglican Church (top) and the Indian Trail Tree (bottom) both serve as symbols of the area's past. The thick walls of the church still stand, even after blood ran red there during the American Revolution and the Civil War. As a safe haven for the wounded of both wars, the church served all. The Indian Trail Tree, for its part, marked a path to a spot for superb fishing. Live oaks not only bend with the wind but also dig their roots deeply before spreading branches.

# Bald Head Island Fishing Gnosis

Sponsored by
**THE BALD HEAD ISLAND CONSERVANCY**

The sandy beaches of Bald Head and Oak Islands are nesting grounds for loggerhead turtles, which can grow to 600 pounds. For millennia, on the full moon in June, these giants lay their eggs in this soft sand. They dig with their hind flippers, burying the eggs, and then let the sun and nature do the rest. Folklore says this rubbery egg has a dent on one end. If one can poke the egg from the other end and make the dent come out, they will get their wish. If they cannot, they are doomed to marry early. About 75 days after they are buried, the eggs begin to hatch. Teams of volunteers have formed turtle watch programs to protect them. Residents turn off all exterior lights, as these little fellows are easily confused. Many years later, five percent or so of the turtles return to within miles of their birthplace to nest again. These areas are designated turtle sanctuaries, and residents are acutely aware of their opportunity to interact with nature.

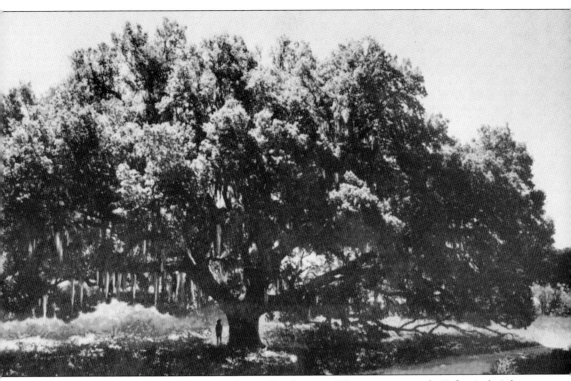

The live oak is one of Southport's most distinctive features. The trees can reach 60 feet in height, with a trunk up to seven feet in diameter. Natives used the acorns as a thickener in cooking.

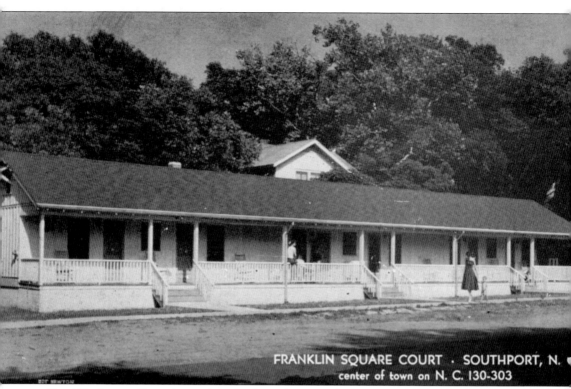

FRANKLIN SQUARE COURT · SOUTHPORT, N.
center of town on N. C. 130-303

Franklin Square Court is seen here in the early 1940s, before the attack on Pearl Harbor drew the United States into World War II. The news of the attack, on December 7, 1941, brought Potter brothers Frank and Bryant of Southport to mind, both of whom were aboard the *Helena* and survived Pearl Harbor.

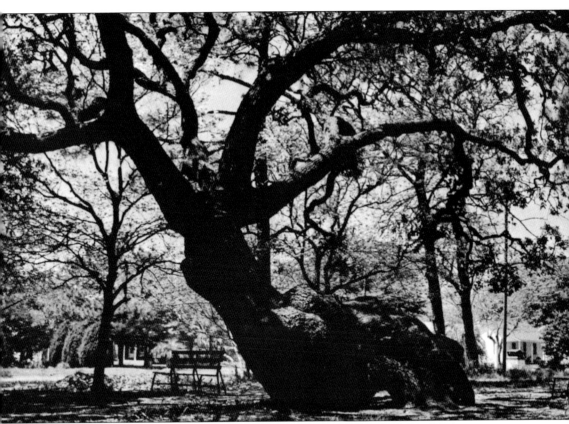

The Indian Trail Tree in Southport appeared in *Ripley's Believe It or Not!* in 1949. There are only about five like it in America. An advertisement from the 1928 *State Port Pilot* newspaper read, "For sale in Southport, The City by the Sea, a desirable lot containing the famous old tree known as The Indian Trail Tree, will sell for $5,000 cash. By 1967, Editor James M. Harper Jr. requests that the city accept the gift of the Indian Trail Tree property to be used as a city park and a memorial to W.B. Keziah." The newspaper wanted to assure the preservation of the famous tree, as it would be a fitting memorial to Bill Keziah, the famous "one-man chamber of commerce" who showed the tree to thousands of visitors. Thankfully, the city heeded the newspaper's advice, and the area will remain a public place for the life of the two-trunk Indian Trail Tree.

The Southport–Fort Fisher ferry, seen here, passes Prices Creek Lighthouse and features views of "Old Baldy" and the Oak Island Lighthouse. The ferry shares the channel with huge container ships and many birds that live on the small channel islands.

A determined group of teachers is seen here at a convention. After education became compulsory in Brunswick County, an attendance officer was hired and the number of enrolled students began to rise, from 182 in 1912 to 217 in 1913.

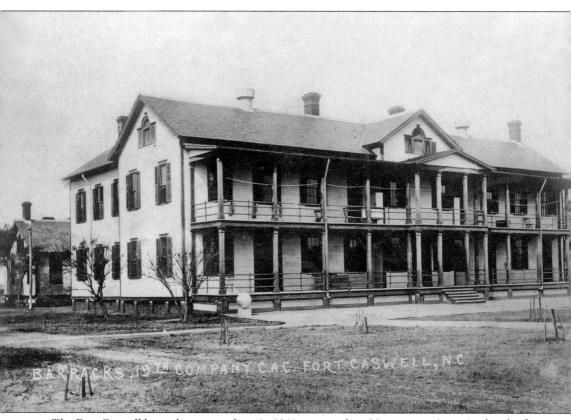

The Fort Caswell barracks are seen here in 1911, a year when 80 new recruits arrived at the fort. The recruits were programmed for success in meeting their goals. All the tools they needed to develop necessary skills were at Fort Caswell. The facility was run like a well-oiled machine, with purpose driving every decision. Even the design of the buildings was considered, as officers lived in homes of a certain size and design depending on their rank and importance.

## HEADQUARTERS U. S. FORCES,

SMITHVILLE, N. C., *May 23*, 1865.

*Post Commissary* :

Will *issue rations* to

*Mrs Anna Spencer & familie*

the following Stores : *5 persons 6 days*

*Total rations 30*

By order of MORRIS F. SHEPPARD,

*Capt. 16th N. Y. Art'y, Com'dg Post.*

*Jno Shelly*

30⁰⁰

In times of conquest, level heads do not always prevail. Union Navy lieutenant William B. Cushing's men were out of control when they ransacked the town of Southport during the Civil War. There was a "to the victors go the spoils" mindset, with little or no control from the top down. Some terrible things happened. The churches were raided, and many records there and elsewhere were wantonly destroyed. When the jewels of the Masonic Lodge were taken, it seemed to be the final blow. Leadership was then changed to another officer, who was able to control the looting. As an example of more peaceful cooperation, these ration receipts were then issued. The pay was in real dollars, and the intent was to make a small attempt at healing deepening wounds. Anna Spencer of Smithville was asked to supply rations for five persons for six days, receiving payment of $30 in exchange. Emotions eventually calmed down, and the jewels taken from the lodge were safely returned undamaged.

CLOSE COVER BEFORE STRIKING

*Southport, N. Carolina*

●

MACK'S
CAFE

*Americana*

NORTH
CAROLINA
WELCOMES
YOU!

Greetings from South-
port, seat of Brunswick
County, N. C.
*Motoring America (Sketch 109)*

6561 Central Ave., Washington 27, D. C.
County Seats 1960. By Edgar A. Perkins

Mack's Café gave out these matchbooks advertising Southport. Today, Southport is known for its Fourth of July celebration, when crowds of 30,000 are not uncommon. Fireworks are now staged from a barge floating in the bay.

In 1977, a committee was formed to decide how to spread the word about the Southport Fourth of July festival to as many people as possible. The committee settled on license plates as a way to do that, thinking that it was an inexpensive way to bring people for the celebration.

In memory of the sesquicentennial of the Civil War, there has been much commemoration. This coin is in honor of Col. William Lamb and all the brave men who fought and died for a cause in which they believed. Imagine walking home to Southport from Appomattox Courthouse at the end of the war. Some did just that, and a few of their stories have been preserved.

*Sunset thru Shrimp nets*                    *Photo Jon Dewr*

Sunset through the shrimp nets seems a fitting goodbye. It all started because of the water, and it is appropriate that the water ends this postcard journey. Shrimping started with a man named Chris Danielson in 1915, who used a sailboat in hopes of profiting from an experiment designed to develop a new industry: the eating of shrimp. Keeping the costs down did not work at first, as, even at $3 per bushel, there were no takers. The time-honored tradition of spreading the risk among others—or using other peoples' money—started slowly, but putting dollars on the line helped promoters think and advertise successfully. When the season opened in 1919, there were enough of these specialized shrimp boats to fill 30 railcars per season with iced or salted shrimp. The experiment worked, and the risk eventually brought rewards. Hopefully, the reader's journey has been as thoughtful, insightful, and rewarding as the author's. It sure was fun to traverse the area's history on a penny postcard path.

# BIBLIOGRAPHY

Carson, Susan S. *Joshua's Dream: A Town with Two Names*. Southport, NC: Carolina Power & Light Company, 1992.

Furstenau, Wolfgang. *Long Beach: A North Carolina Town: Its Origin and History*. Self-published, 1995.

Harper, Margaret, Jim, and Ed. *The Way It Was*. Southport, NC: the *State Port Pilot*, 2000.

Herring, Ethel and Carolee Williams. *Fort Caswell in War and Peace*. Oak Island, NC: North Carolina Baptist Assembly, 1999.

Johnson, Donald Knute. *Southport Secrets*. Southport, NC: Southport Historical Society Inc., 1998.

Lee, Lawrence. *The History of Brunswick County, North Carolina*. Charlotte, NC: Heritage Press, 1980.

Lounsbury, Carl. *The Architecture of Southport*. Southport, NC: Southport Historical Society Inc., 1986.

Maisel, Larry. *Before We Were Quaint*. Southport, NC: Southport Historical Society Inc., 2009.

Reeves, Bill. *Southport (Smithville): A Chronology*. Vols. 2–4. Southport, NC: Southport Historical Society Inc., 1992, 1996, and 1999.

Redlow, Franda D. *The Story of Brunswick Town and Fort Anderson*. Wilmington, NC: Dram Tree Books, 2005.

Stick, David. *Bald Head: A History of Smith Island and Cape Fear*. Wendell, NC: Broadfoot Publishing Company, 1985.

# DISCOVER THOUSANDS OF LOCAL HISTORY BOOKS FEATURING MILLIONS OF VINTAGE IMAGES

Arcadia Publishing, the leading local history publisher in the United States, is committed to making history accessible and meaningful through publishing books that celebrate and preserve the heritage of America's people and places.

Find more books like this at
**www.arcadiapublishing.com**

Search for your hometown history, your old stomping grounds, and even your favorite sports team.

Consistent with our mission to preserve history on a local level, this book was printed in South Carolina on American-made paper and manufactured entirely in the United States. Products carrying the accredited Forest Stewardship Council (FSC) label are printed on 100 percent FSC-certified paper.

MADE IN THE USA